BEST FRIENDS FOREVER

BEST FRIENDS
FOREVER

THE GREATEST COLLECTION OF TAXIDERMY DOGS ON EARTH

— BY J.D. POWE —

— PHOTOGRAPHY BY ZACH ISHMAEL —

CERNUNNOS

DEDICATION

To my rescue dogs Tyrone and Ruby, the latter of which formally endorsed
the contents of this book by barking twice in affirmation.

TABLE OF CONTENTS

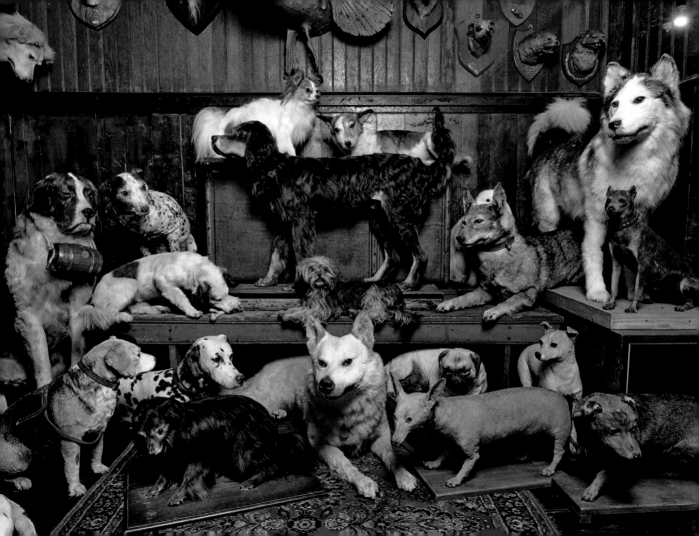

INTRODUCTION

As a lifelong enthusiast of natural history, taxidermy has always held a certain fascination for me. What I describe as a passion, the less sympathetic among us might characterize as an affliction, perhaps justifiably so. I got started early through regular trips to the American Museum of Natural History on New York City's Upper West Side. Many hours of my formative years were spent collecting and organizing rocks, seashells, fossils, and insects. From there, I moved on to raising and exhibiting ornamental poultry, including rare breeds of chickens, pheasants, and peafowl. And, yes, I received my share of impressive accolades, including county Grand Champion of Poultry Showmanship three years in a row. These early experiences provided essential fuel to an already smoldering curiosity about the natural world and our place within it, and this propelled me to conduct undergraduate studies at Harvard, where I studied the history of science with luminaries such as Stephen Jay Gould.

Yet, despite my fascination with the natural world, I came to the conclusion that a purely academic career path was not for me. I conjured up a number of decidedly pragmatic rationalizations in support of this conclusion. To this day, I'm not certain that I found any of them especially compelling. But, they were enough to convince me that I would surely struggle to support myself financially as a zoologist or paleontologist. Moreover, the pressure to publish arcane monographs on topics of dubious interest would most certainly catch up with me before long. Perhaps most importantly, the golden age of great scientific discoveries was over, or so I told myself. The vast expanse of the unknown had long since yielded its dominion to its insipid cousin, the verifiable fact; what was left to speculation were just a few piteous scraps fallen from the table of technological innovation.

So, what was a disillusioned would-be scientist to do? Well, inspired largely by my parents, both of whom are lifelong educators and entrepreneurs, I ultimately choose to pursue a career at the nexus of educational publishing and technology. Despite this more traditional career path, my interest in the natural sciences—and, by extension, *historical taxidermy*—continued to percolate just below the surface.

But, this book really isn't about me or my life choices: It's about dogs, taxidermy dogs, specifically. Its publication was the result of a number of unexpected events, chance encounters, and other entirely unpredictable circumstances. There is no convenient narrative or logical thread that ties it all neatly together, making sense of the irrefutably bizarre. Though surely cliché, it is fair to say that the pages that follow do raise a great many questions, but provide few definitive answers. One peculiar tidbit is that I do not even consider myself a "dog person," with obligatory apologies proffered to Ruby and the late Tyrone, the rescue dogs to whom this book is dedicated. To be clear, I do love dogs, the two aforementioned canines in particular, but I'm not an individual that is so dog-obsessed that I welcome the sensation created by the prodigious slobber of an adoring pooch with outstretched tongue pressed against my face. We all have our limits, and any exchange of saliva involving two or more species, one of them being human, is where I draw the line.

But, to consider what this book is really about, I think it may be most useful to start by clarifying what it is not. Despite my occasional regrets about not pursuing a career in academia, this is decidedly not a belated attempt at scholarly redemption. It is not a research-based treatise on the evolution of dog breed morphology over the centuries, their temperament, or their incredible phenotypic diversity. It is not an explanation of taxidermy techniques nor a compendium on historical taxidermists and their works. It is also not an attempt to contextualize the Victorian psyche and prevailing attitudes toward nature and animal husbandry at the turn of the nineteenth century. These themes have been explored in impressive detail by many scholars and dedicated collectors, including John Whitenight, Errol Fuller, and Dr. Pat Morris, all of whom have served as inspiration for my journey as a collector. So, what makes dead dogs preserved through the art and science of taxidermy a worthy choice of subject matter?

As an avid collector of antique taxidermy and natural history, I have had the opportunity to appreciate— *and even acquire*—exceedingly rare specimens, including examples of extinct species, including the leg bone of a Dodo and the feather of a Great Auk. Many such items have provenances tying them to historically significant collections and call to mind an era that now seems far removed from our modern sensibilities and preoccupations. I vividly recall the adrenaline rush I experienced when purchasing my first taxidermy passenger pigeon, a perhaps singularly iconic exemplar of human-induced extinction. As the auctioneer's hammer fell with my bid in the lead, I was entirely consumed by the awesome power of possessing the unattainable while feeling overwhelmed by the fragility of existence. To think that flocks of this once-ubiquitous migratory bird blackened the skies above North American just over a century ago is at once devastating and inspiring in its implications.

In the relatively intimate circle of antique taxidermy enthusiasts, extinct specimens are the proverbial holy grail; the glorious centerpiece of any modern-day cabinet of curiosities. Though a relative novice in collecting circles with a mere ten years under my belt, I have pursued the rare and unusual with an unusual resolve.

My pursuit of the rare led me to the Gowanus area of Brooklyn and the Morbid Anatomy Museum, the now shuttered monument to the obscure that offered uniquely unfettered access to historical, cultural, and scientific objects drawn from some of the country's most astounding private collections. Though relatively modest in its proportions, visitors to its gallery-style exhibition rooms were treated to finely curated exhibits that varied as widely as the objects on display. To the extent that there was a unifying principle, it might be described as an attempt to restore a sense of lost curiosity; and perhaps more profoundly, an intimacy with death itself.

I was honored when the museum's cofounder and creative director, author Joanna Ebenstein, asked me to curate an exhibit on historical taxidermy that was being scheduled for the summer of 2016. I quickly set to work creating a list of my favorite taxidermy genres and themes: Extinct species, rare and spectacular birds, zoomorphic functional objects such as inkwells and ashtrays crafted from animal feet, wonders of the sea, sideshow and circus "freaks," "crap" taxidermy, and anthropomorphic dioramas featuring boxing squirrels and smoking rabbits, were among my chosen curatorial categories. To populate each vignette, I drew heavily from my own growing collection of historical specimens and from the ranks of the numerous dedicated collectors I had become acquainted with in my quest for the unusual.

The centerpiece of the exhibit was an ambitious anthropomorphic work depicting nineteen tiny kittens dressed in full Victorian wedding regalia. "The Kittens' Wedding," created in the 1890s by provincial taxidermist Walter Potter, was sold in 2003 at Bonhams auction house in the United Kingdom for £21,150 GBP, or approximately $30,000 USD. It later came to auction in 2016 as part of the estate of Chicago art dealer Candice B. Groot, where it sold for $140,000, inclusive of fees. Thereafter, the jaw-dropping glass enclosure found its way to a private collection of Ms. Sabrina Hansen, a New York collector who paid an undisclosed sum for the piece before generously lending it to the museum for my exhibit.

The diminutive kittens, fully dressed with hand-sewn dresses, jewelry, and smoking jackets, transcend the common notions of what taxidermy is and generated enough intrigue for the exhibit to receive extensive

news coverage, most notably in the *New York Times*. This was a welcome validation for enthusiasts of the obscure, myself included. Yet, upon repeated visits to the exhibit during its several-month run, I could not help but notice a consistent pattern.

Already well-known in taxidermy collecting circles courtesy of both the Internet and a popular book on Walter Potter by Dr. Pat Morris and Ms. Ebenstein, the kittens were clearly a huge attraction. Many visitors came a considerable distance to see them in person and more than a few made cross-country trips by car. This was not especially surprising. In reality, other sections of the exhibit were relegated to competing for second place in terms of their ability to inspire and amaze. Though the battle for runner-up was never officially adjudicated, it soon became evident that the assortment of rare and extinct species that were closest to the center of my collecting focus weren't even in the running. Instead, it was the wall at center right that visitors found most captivating. This section became informally known as the "Wall of Dogs," and the conversations that surrounded it expressed a mix of emotions ranging from outright disgust to untethered joy. So, it was not the rarest of the rare that

inspired the greatest sense of wonder and awe; it was the familiar, the pedestrian, the mundane.

To be clear, most onlookers had never seen a taxidermy dog, let alone almost twenty of them stacked in three neatly organized parallel towers. So, in this sense, the display was unusual. Yet, few, if any, animals are more familiar to humans than dogs. It was through this experience that I became intrigued by the complex emotional reactions that human beings have when viewing taxidermy pets. Part of this tension surely relates to the fact that taxidermy, particularly in the United States, is closely associated with sport hunting. Accordingly, people assume that a "stuffed" dog might well have been killed for the purpose . . . blasted out of existence as if it were a prime twelve-point buck on the first day of hunting season. Of course, it likely goes without saying that barring what might be a few very rare exceptions, dogs were not hunted or killed to produce decorative taxidermy trophies.

Instead, the tradition of preserving beloved family pets goes back a very long time, but likely reached the height of its popularity in Victorian England. Several examples in this book date to the 1850s while many

others are just a few decades later. If these surviving examples are any indication, the practice was a popular one, particularly for those that could afford it. At the same time, the practice of taxidermy was reaching its zenith in terms of preservation techniques and artistry. Preserved specimens in ornate glass domes and diorama cases were routinely making their way into both country retreats and urban homes of the well-heeled set. Decorating in this manner became a popular method of expressing cosmopolitan worldliness and dominion over nature.

As the practice of taxidermy was evolving rapidly during the waning decades of the nineteenth century, particularly in the area of preservation techniques and popular acceptance as a legitimate and aspirational form of interior decor, it seemed only natural that rather than bury or cremate a four-legged family member, an individual of means might choose to preserve their pet via this emerging art form. At the time, it was scarcely considered what would become of these treasured specimens over time, particularly after the departure of their erstwhile owners from the earthly realm. Accordingly, in an ironic twist of fate, examples of taxidermy dogs from this period have

long outlived their owners, and remain beloved treasures generations after the passing of the living animal. This book is an attempt to showcase some examples that have withstood the ultimate test of time and now stand as Ozymandian testaments to human frailty and ingenuity.

For most of the dog specimens in this book, available information and history is decidedly thin. With a few exceptions, the true names of these beloved pets have long been forgotten. Still, speculating about their respective histories is part and parcel of the experience of engaging with these objects of wonder. What were their owners like? When and where did they live? How did they die? And, decades after the demise of their rightful owners, what should become of these lost souls? Do they deserve to be preserved as historical curiosities? To be revered as objects of desire? To be shunned as taboo? Why, for example, does it remain common practice to steadfastly preserve the cremated remains of a beloved and irreplaceable pet, perhaps in a display urn set upon a fireplace mantel, yet a more lifelike effigy in the form of taxidermy is widely perceived as gratuitously provocative or even macabre? Largely through its images, this book

explores these questions in all of their messy and incongruous sentimentality.

While most of the dogs featured on these pages are antique specimens, a few modern examples are also included, and these are often the catalyst for feelings of even deeper disgust. The practice of taxidermy on pets is enjoying a bit of a resurgence today and small studios and large companies have established themselves as specialists in the art of pet preservation. The advent of new techniques, such as freeze-drying, have lowered the cost and complexity of our attempts to act as willing accomplices to our canine wards in their attempts to evade the certainty of death, or at least decomposition. Still, it remains true that many owners are aghast when confronted by the taxidermied form of their once-living lap dog and fail to collect the mounted specimen following its completion, leaving the taxidermist to find the animals new homes devoid of the pervasive bias that comes with intimate knowledge of the living form.

The emotional connection that we humans have with our pets is the very thing that makes it difficult for many to stomach the sight of taxidermy dogs. Even the artistic genius of the most talented taxidermist may be betrayed by a dedicated dog owner's encyclopedic knowledge of every nuance of the living animal's posture and facial expressions. This uniquely human dynamic is surely one of the reasons why, after a decade of collecting rare and exotic taxidermy specimens, I developed an interest in taxidermy dogs.

Though they originate from multiple individual collections, the 150 specimens featured in this book are believed to be one of the largest collections of antique taxidermy dogs ever assembled in a single location outside of a museum. With only a precious few exceptions, including the United Kingdom's Tring museum, most museums of natural history take little notice of domestic animals, dogs included. The fact that many of the dogs in this book have been preserved and protected by generations of individuals with no personal connection to the living animal makes their existence all the more remarkable. Despite the staggering advances of modern science from space exploration to the commercial availability of pet cloning, the survival of these dogs, some after nearly two hundred years, suggests that the human capacity for wonder and curiosity remains very much intact.

Dating back to the Victorian era, the vast majority of taxidermy dogs were preserved as "full mounts." That is, the style of preparation in which the entire body of an animal is preserved for posterity. The style also had the distinct advantage (and challenge) of being most similar to the living animal, at least when faithfully represented by a competent practitioner. However, unlike today, photos of people with pet dogs from the Victorian era were relatively rare. It would have been more likely to have a painting of the dog commissioned during its lifetime than a photograph, so taxidermists of the time may have had little to work with in terms of reference material to help them capture the nuances of the living form.

While we are generally unable to assess the degree to which antique taxidermy examples faithfully represented their living counterparts, the most accomplished taxidermists of the nineteenth century certainly created more than a few very convincing dogs. And, in the hands of modern day owners with a penchant for practical jokes, these antiques continue to ward off would-be intruders and startle the unsuspecting among us.

The few contemporary examples included in these pages are invariably of this style. For modern-day pet owners that choose the path of taxidermy as a mechanism to celebrate the life of a beloved and loyal friend, it would seem that full mount presentations best represent the desired level of verisimilitude.

I
UNLEASHED

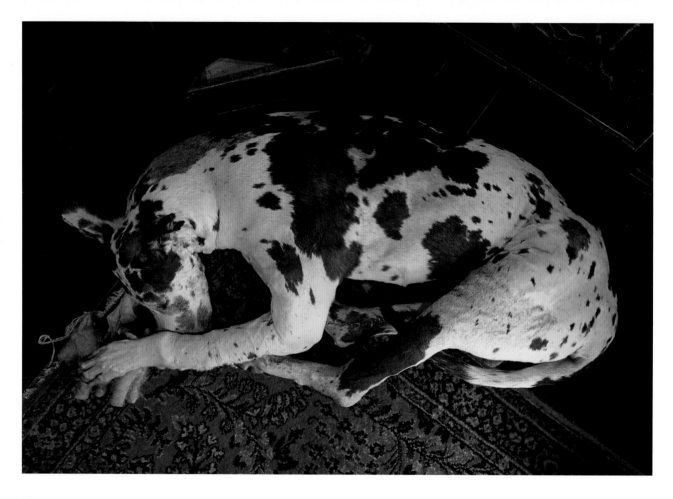

Harlequin Great Dane in Repose

A stunning late-twentieth-century example
of a harlequin Great Dane, positioned in
permanent repose with what was perhaps
a favorite toy. According to the owner,
this particular example caused more than
a few visitors to the home to recoil in
amazement after realizing their attempts
to show affection would not be reciprocated.

Trixie, the Train Dog

A small black and tan terrier-type dog
reputedly won adoration as a longtime
inhabitant of a c. 1900 English train station
prior to her passing. Her red leather collar
is adorned with a bell and an engraved tag
that reads "My name is Trixie. I belong
to Mapp, 2 Railway Cottages, Coalport."

LEFT

A Petite Terrier

A small but excellent example of a vintage specimen of indeterminate breed, presented in a reclining, yet attentive, pose. This fellow appears ready to answer the call of his owner and leap into action at any moment.

RIGHT

Reclining Husky

Originating from a Canadian collection, this Siberian Husky has been permanently immortalized in a resting position, as if recharging after a long journey pulling a sled.

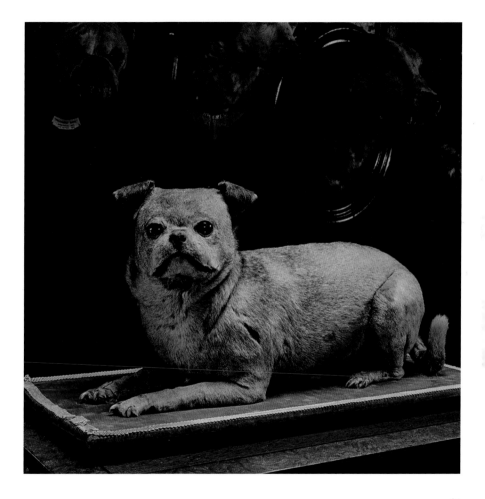

LEFT

The Saatchi Bulldog

Though his name has been lost to time, this Victorian-era English bulldog is believed to be one of the most expensive taxidermy dogs ever sold at auction. In 2012, advertising impresario Charles Saatchi bid an astounding £19,375 including premium (or approximately $26,000 USD) to secure the rights to re-home this recalcitrant-looking fellow at Christie's auction of London-based antique dealer Will Fisher's collection.

RIGHT

A Stately Pug

This sphinxlike pose of this Victorian pug clearly suggests that the living individual was especially wise. Perhaps untold treasures await those capable of solving her riddles.

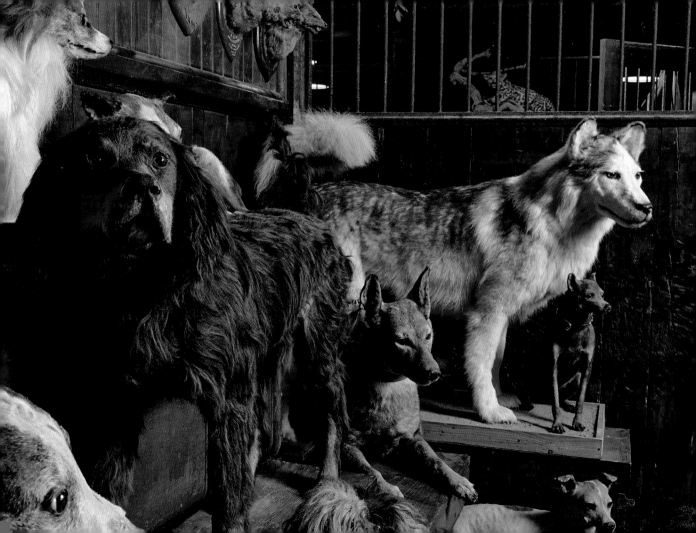

Lord Tailwagger (left)

A Gordon setter dated to 1910 appears anxious to resume his responsibilities as a hunting dog. According to the accompanying brass medallion, this particular individual has the added distinction of being a proud member of the Tail Waggers Club, a society of dog fanciers based in London in the early 1900s.

Majestic Husky (right)

An impressive vintage example of a Siberian Husky originating from a collection in Lithuania. This working dog remains in excellent condition long after death and is a powerful exemplar of this robust breed.

Dog on a Bone

This dog is expertly presented chewing on a bone that is held in place via a wire armature that extends from the left front paw. It is said this specimen once formed part of a Native-American-themed diorama on display at the American Museum of Natural History, in New York City, though the claim is not verifiable.

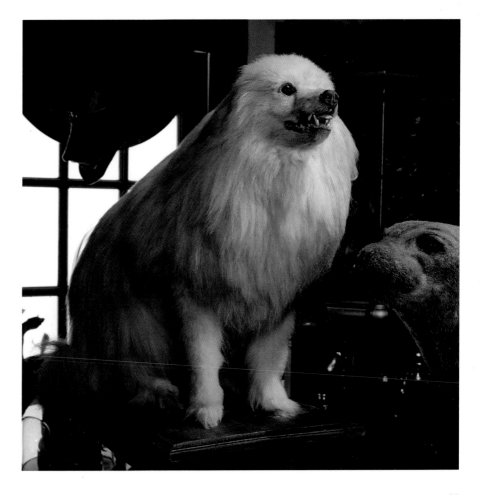

LEFT

Kickstart the Wanderer

Kickstart was a much-adored British countryside dog who made the fatal mistake of repeatedly wandering onto a neighboring farmer's property in the company of a known canine associate and frequent traveling companion. Frustrated with their repeated and allegedly mischievous intrusions, the irate farmer exacted the ultimate form of vigilante justice, shooting both dogs before Kickstart's owner could intervene. Distraught over the loss of his beloved Kickstart, the owner had him preserved by a local taxidermist to be fondly remembered for eternity, or at least as long as circumstances would reasonably allow.

RIGHT

An Eager-to-Please Spitz

This small, long haired dog is likely related to the spitz breed, which also includes the American Eskimo dog. This particular specimen is presented with a rather intense smile and an extended tongue.

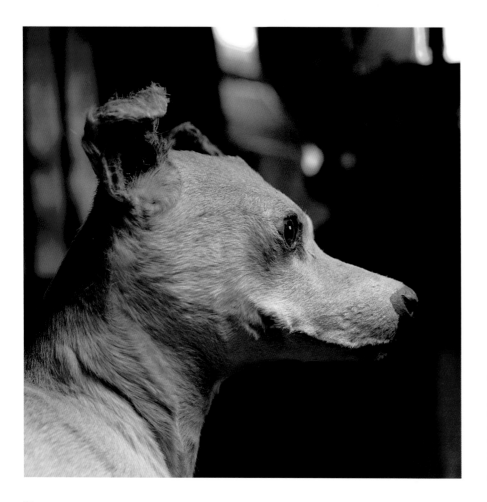

An Alert Terrier

Though not especially rare or unusual,
this statuesque study of a terrier from
the early twentieth century has a decidedly
plucky look.

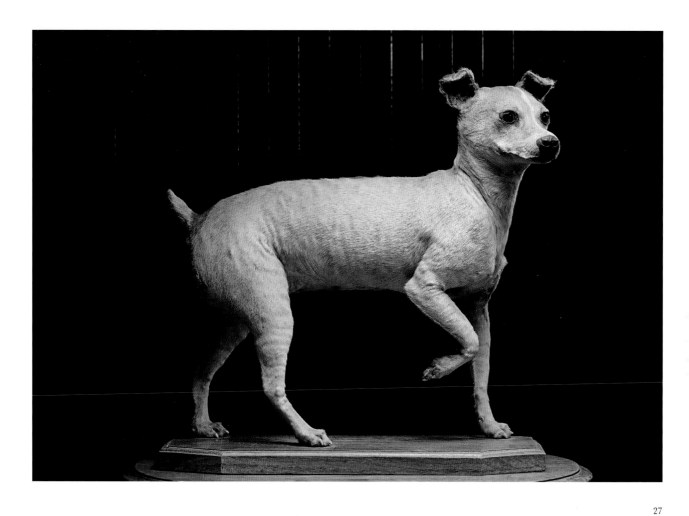

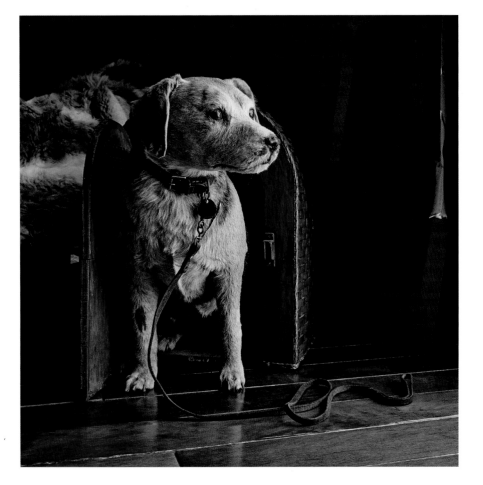

LEFT

Beagle on Leash

It is likely that this mid-twentieth-century example retains his original leash and collar. He is included in the unleashed section of this book purely for the sake of irony.

RIGHT

Leader of the Pack

Veteran taxidermist Colin Griffith has preserved many dogs for bereaved owners in his U.K.-based studio, Tribute Wildlife Art, including the examples shown on this page. He notes, "Dogs represent a huge challenge technically and there is also the difficulty of dealing with their emotionally distraught owners. In their vulnerable state, many are willing to pay exorbitant prices to preserve their pet, but I have made it my policy not to take advantage of this. It's difficult enough for an owner to lose their dog without the worry of a huge bill if they opt for the use of my services."

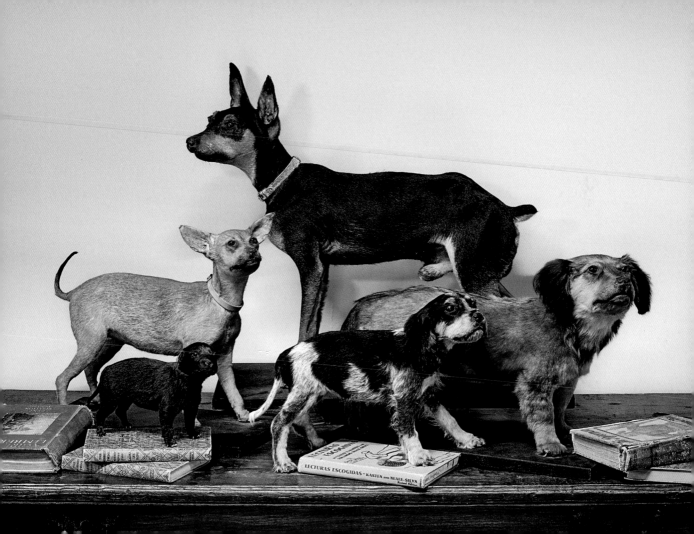

French Long-Haired Dachshund

A stunningly realistic long-haired
dachshund, believed to be of French
origin. This example is perhaps the most
lifelike of any featured in this book.
Mid twentieth century.

Brittany Spaniel in Repose

A very fine contemporary example
of Brittany spaniel in repose. The unknown
taxidermist has considered every detail
in its preparation, including the subtle
contour of the right jowl overhanging
the front leg. In this case, the spaniel
in the foreground has a bedding
companion in the form of a midcentury
taxidermy dachshund.

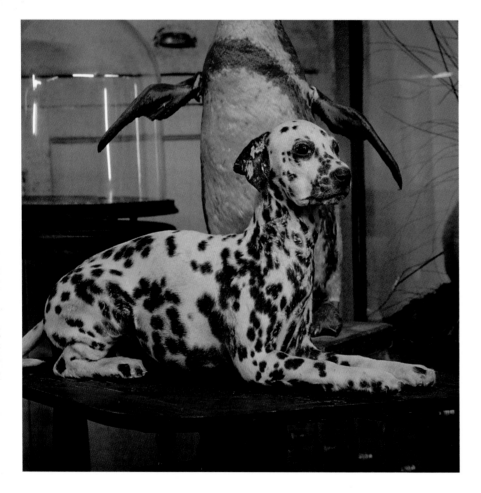

LEFT

Dalmatian Puppy

A Dalmatian puppy from an American collection displayed alongside a color-coordinated antique penguin.

RIGHT

Guardian of the Flock

An antique example of a large working dog, likely an Italian Maremma sheepdog or a Great Pyrenees, this majestic beauty likely spent its living years steadfastly guarding flocks of herd animals such as sheep or goats before being preserved through taxidermy.

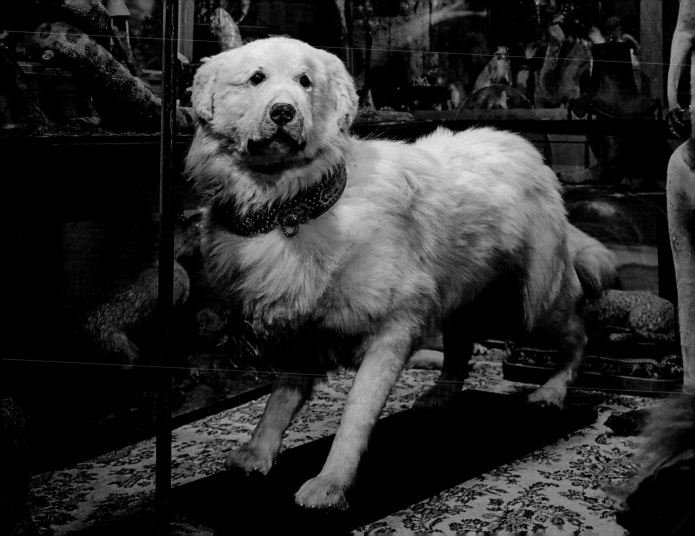

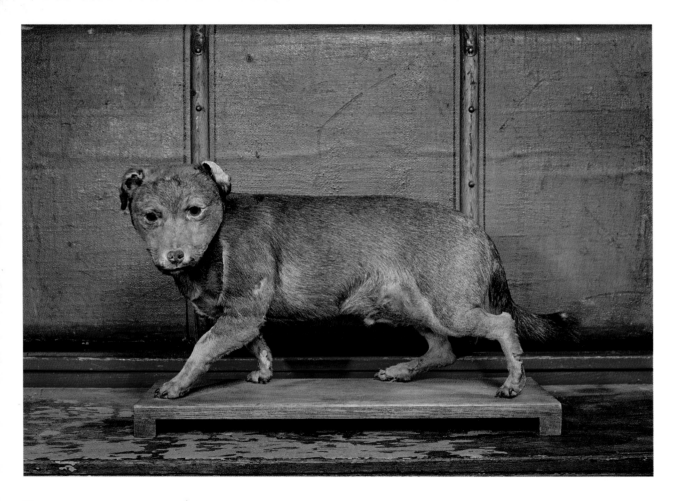

Tireless Terrier

A compact terrier specimen from the early
1900s whose posture suggests the tireless
and efficient work ethic that is typical
of the terrier breeds.

English Mastiff

A large and impressive antique Mastiff
specimen, realistically mounted
in seated position and originating
from a French collection.

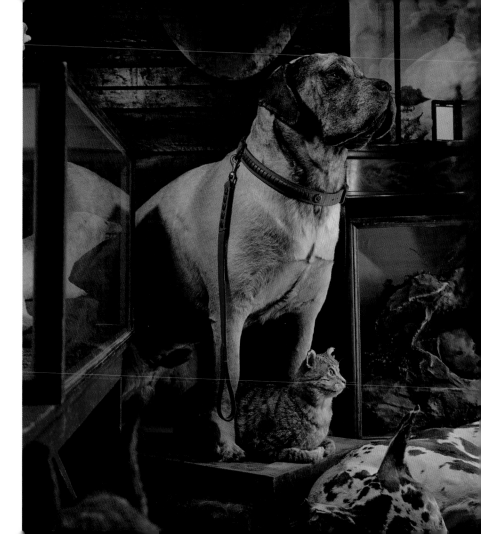

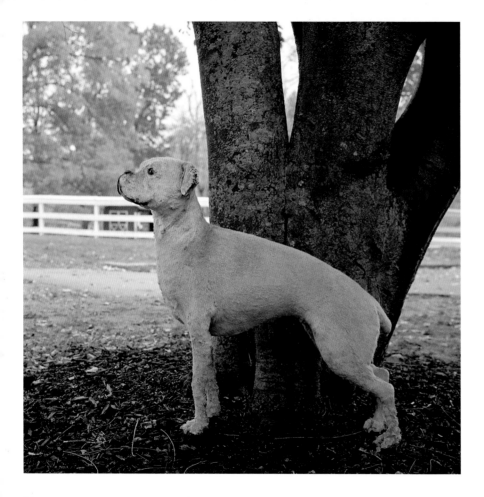

LEFT

Humperdinck's Boxer

The stately example of a boxer-type
dog is a bit worn around the edges,
but unequivocally charming. It is claimed
he was once owed by British pop music
icon Engelbert Humperdinck, who scored
multiple chart-topping hit singles
in the 1960s.

RIGHT

Antique Spotted Dog

An impressive and lifelike example
of a spotted dog of unknown breed
with closely cropped ears.

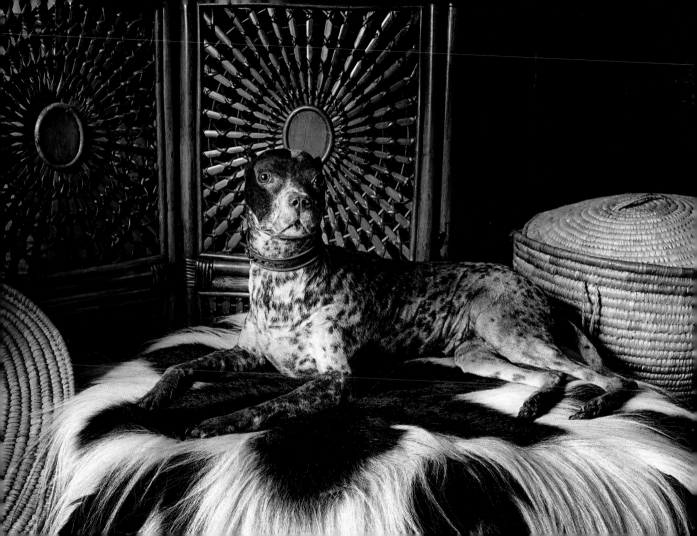

Relaxed Terrier

This charming floppy-eared fellow is of French origin and certainly appears to be living his best life after death.

Antique Boxer

This statuesque antique boxer has apparently abandoned his usual post presiding over a Victorian-themed barroom in an American country home and gone for an unsupervised walk in the foreground of some ironic signage.

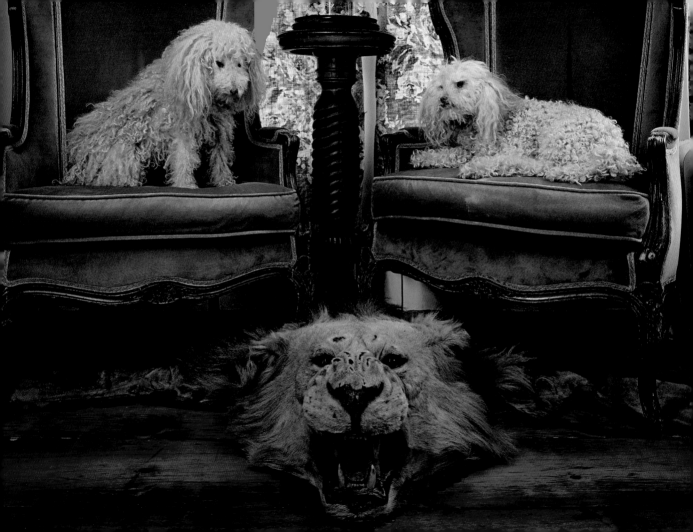

Pair of Poodles

A pair of antique French poodles,
undoubtedly by the same maker.
One seems rather intrigued by the large
kitty at the foot of his velvet chair,
an antique lion that was allegedly taken
in the wild by none other than writer
Ernest Hemingway.

Leon, the Saint Bernard (left)

A superb example of a French Saint Bernard,
Leon died due to poisoning at the early age
of three, according to the inscription on
the accompanying brass plaque, which also
bears his name.

**Black and White Sporting Dog
(right)**

A nineteenth-century sporting dog
in an uncomfortable-looking pose,
the fellow just behind the Saint Bernard
in this photo appears to be leaning
in to dish the latest pack gossip.

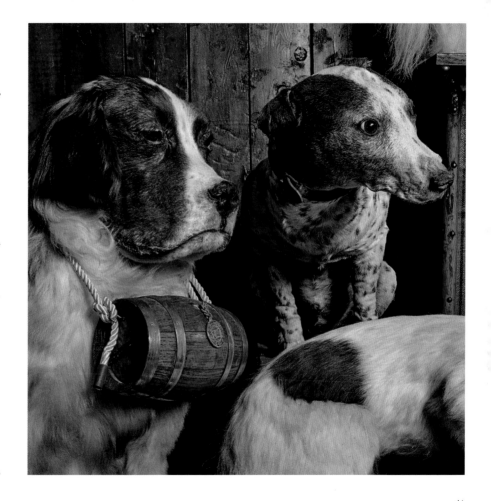

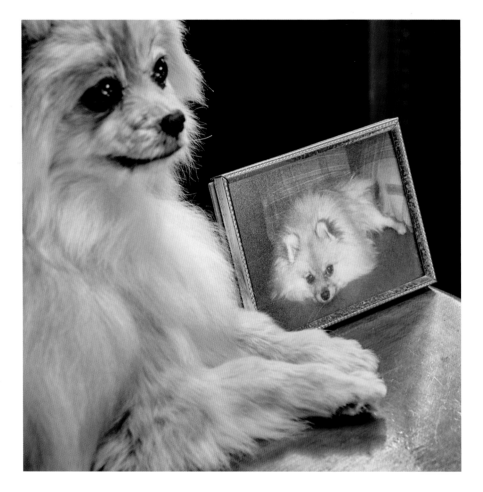

LEFT

Pomeranian with Photo

A decidedly fluffy vintage Pomeranian, this fellow is presented with a framed photograph of his living self. The taxidermy likeness is quite convincing.

RIGHT

A Curious Fellow

This mixed breed specimen of French origin has found an ideal vantage point from which to survey his territory for would-be intruders.

Unlike the more typical full mount, head mounts could never be confused with a living specimen. In many ways, disembodied heads are taxidermy's most iconic form factor: they are likely to be the first mental image conjured at the mention of the word.

A well-executed head mount by a master of the trade is more akin to a character study of the animal, showcasing its most distinctive facial features and characteristics. One could easily question whether the authentic character of, say, an antelope, is ever truly on display; or, for that matter, whether a taxidermist's portrayal of a menacing grizzly bear exaggerated its ferocity in order to inflate the hunter's sense of accomplishment. Be it an antelope or a bear, such examples are relatively commonplace in museums, private collections, hunting lodges, and even restaurants and retail boutiques. For most people today, viewing the head of a taxidermy dog is a peculiar experience that triggers singularly unfamiliar and spine-tingling sensations.

Perhaps the first and foremost question relates to why a dog owner would choose to go in this direction instead of opting for a more lifelike postmortem rendition of a devoted and loyal companion. There are, of course, the practical considerations: head mounts require less space to display and are less costly to produce than their full-bodied counterparts. Surely, such reasoning was a factor. But, when it came to nineteenth-century attitudes about preserving animals, the object was not simply to recreate the living, but to honor and glorify the sacrifice of the vanquished. Of course, dogs were not "vanquished" in the sense of being hunted. Ultimately, they fell victim to the scourge of time itself. So, like a marble bust of Pericles, taxidermy dog heads were an homage to the living form; a stylized tribute designed to stand the test of time.

II
HEADS UP

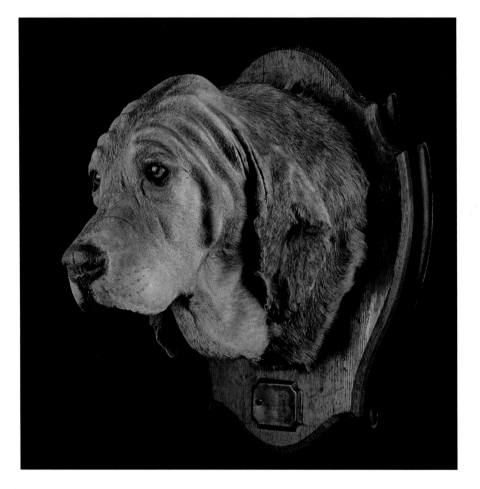

Hugh, the Bloodhound

A stunning and very rare early example of a bloodhound in original condition, dated 1851 on the engraved brass plaque accompanying the wooden shield. The unknown taxidermist achieved an unusual level of realism in crafting this specimen, which, at approximately 170 years old, is likely the oldest in this book. That's nearly 1,200 in dog years for the mathematics enthusiasts among us.

Obedience Class of Circa 1900

The heads in this photo originate from a variety of collections around the world. With thirty-seven specimens in total, this group could conceivably be the largest ever assembled for display on a single wall. Most of the examples date from the late 1800s and early 1900s, though there are a few later examples that have made the cut, so to speak.

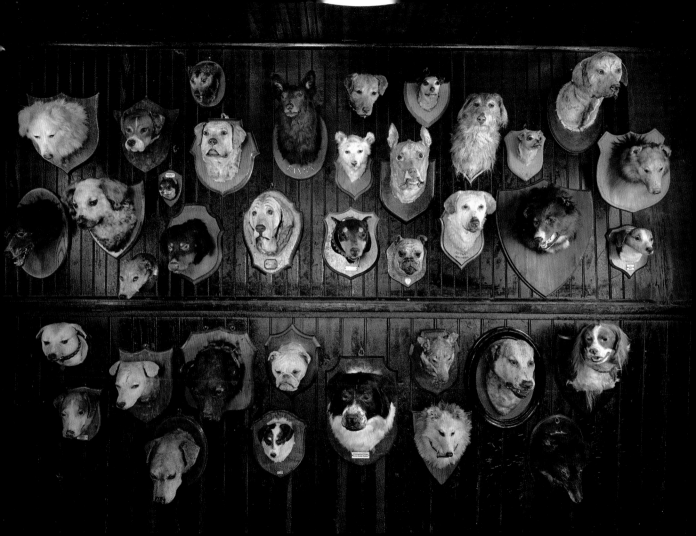

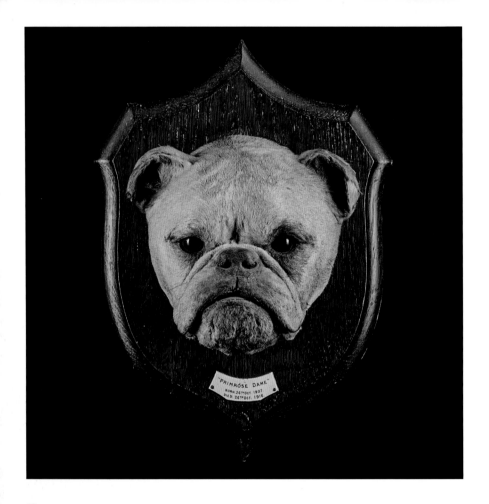

"PRIMRÓSE DAME"
BORN 26TH OCT 1907
DIED 26TH OCT 1916

The Primrose Dame

Perhaps the most striking example of a taxidermy dog head to be offered at a public sale in recent years, the incongruously named Primrose Dame (1907–1916) hailed from The Jungle, the famed taxidermy studio founded by Rowland Ward, Victorian England's most prolific taxidermist.
The Dame was one of the premier lots in Sworders' Out of the Ordinary auction held in February 2018.

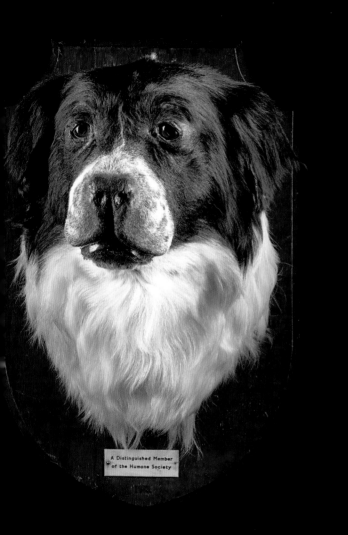

A Distinguished Member
of the Humane Society

Landseer Newfoundland

A truly majestic example of a Landseer
Newfoundland on a wooden shield
in the style of Victorian taxidermist
Edward Gerrard, a leading competitor
of Rowland Ward. Curiously, the
accompanying ivorine label bears the
inscription "A Distringuished Member
of the Humane Society."

Great Dane

This antique Great Dane has a face that only a mother—or a very dedicated collector—could love. This googly-eyed, slack-jowled fellow has visibly exposed teeth, indicating that the skull of the animal was likely used in the creation of the taxidermy form.

English Fox Hound

This impressive and well-preserved fox hound mounted on an antique shield from a U.K. collection is the embodiment of a downward-facing dog.

Fanny the Herd Dog

The delightfully named Fanny has no shortage of character. An antique piece presented on an original wooden shield with her name embossed in gold lettering.

Bess the Beagle

Bess lived a relatively short life from 1938 to 1941 and was preserved by the legendary taxidermy studios of Peter Spicer & Sons, of Leamington Spa. Spicer was best known for his work on British small-game animals, such as foxes and otters. Examples of taxidermy dogs by this master of the trade are very rare.

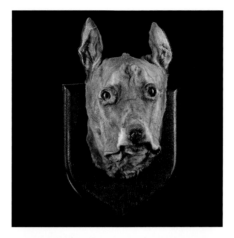

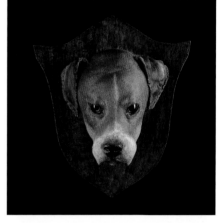

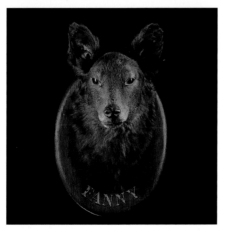

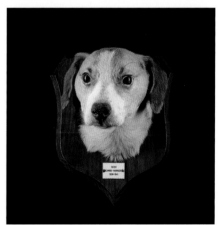

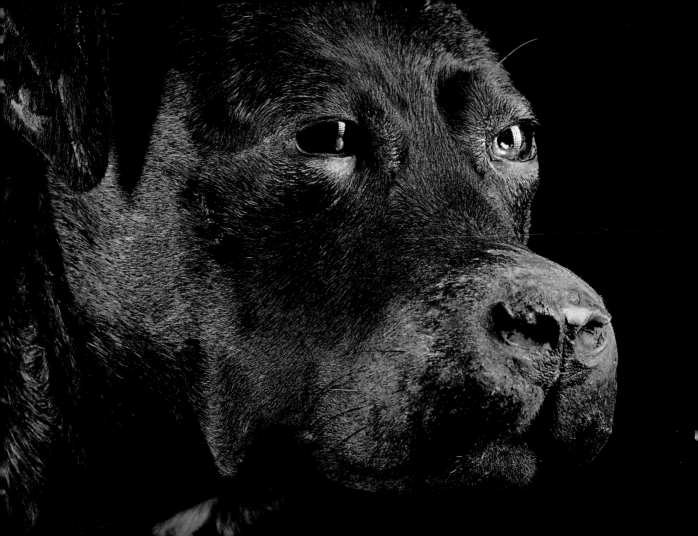

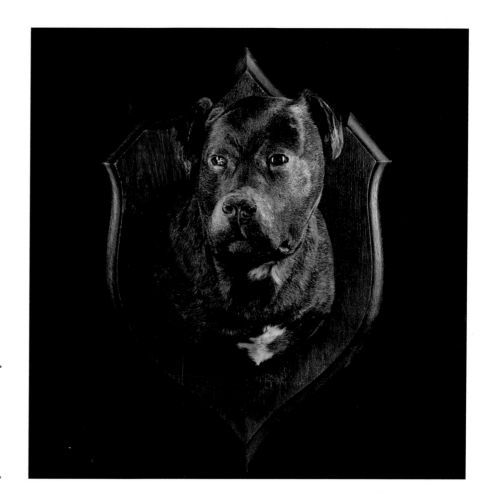

A Superb Bullmastiff

A regal example of a black bullmastiff,
mounted by Rowland Ward, and on
an original shield. This impressive animal
is said to have been a personal pet of the
Ward family. Early twentieth century.

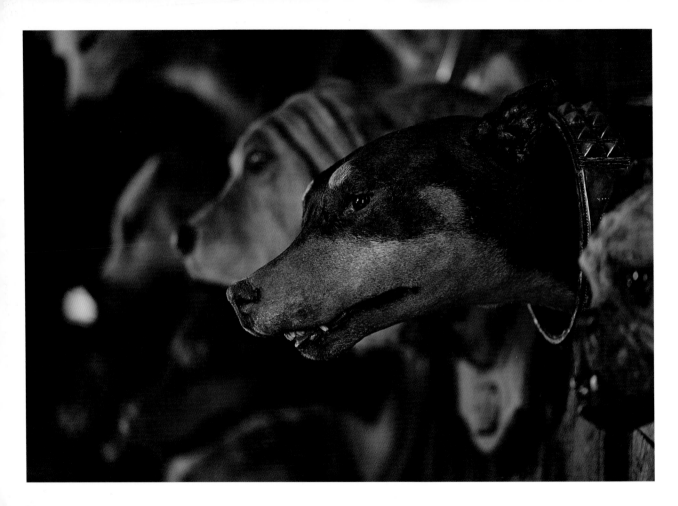

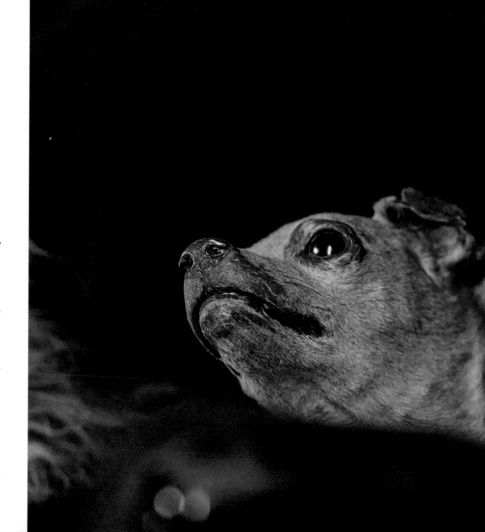

LEFT

Bruno, Doberman Pinscher

"Bruno," the doberman pinscher, formerly
of the collection of the late Candice B. Groot,
the well-known Chicago art collector
and taxidermy enthusiast. Mid to late
20th century.

RIGHT

Jack Russell Terrier

A Jack Russell terrier on an atypical fabric-
covered shield, this little fellow has begun
to show his age . . . perhaps understandably
after some 980 dog years.

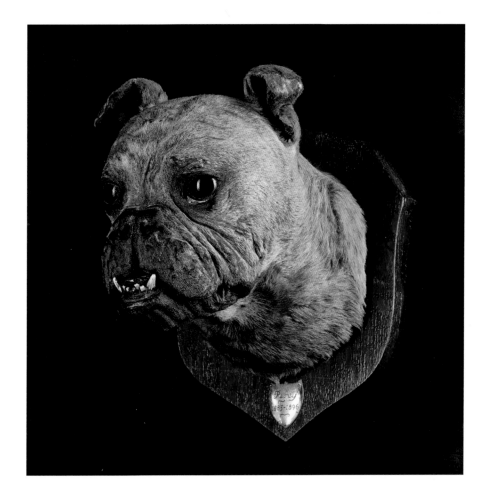

Percy the Bulldog

Dated 1896, Percy is an early example of a British bulldog and has the trademark underbite grin characteristic of the breed, but has a less wrinkled face than modern examples since that characteristic has been selected for over generations of breeding.

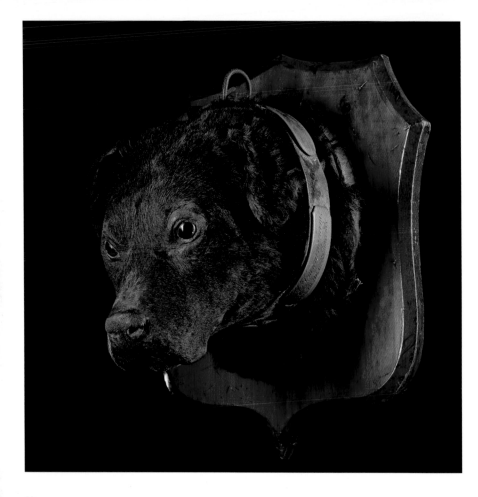

LEFT

Polar Bear Expedition Head

This large example of a working dog breed
was preserved with the original collar,
inscribed "H.M. Cunningham, Polar Bear
Expedition." The current owner assumed
the dog might have participated in a polar
bear hunt, but the inscription is more
likely a reference to the little-known Allied
military campaign against Bolshevik forces
in Northern Russia near the end of World
War I. Accordingly, this dog is presumed
to have seen some action on the front
lines, which makes his preservation
all the more remarkable.

RIGHT

An Unusual Greyhound

A stunning example of a racing dog in
the greyhound family, with a rare and
highly unusual collar carved from wood.
This dog may well have been a champion
of the racecourse in its lifetime.

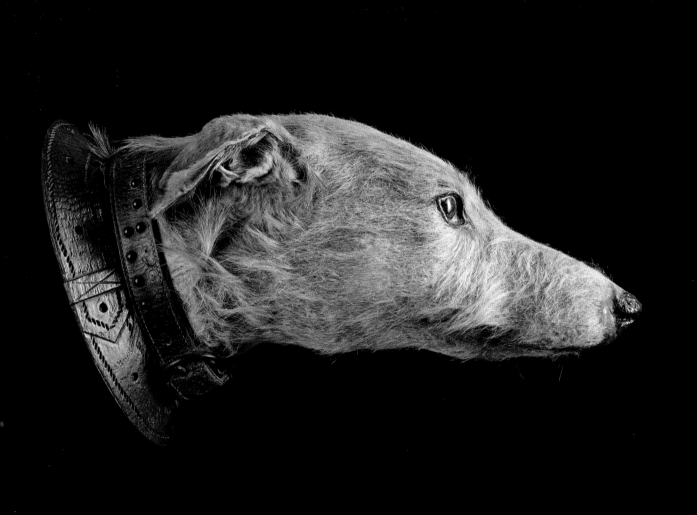

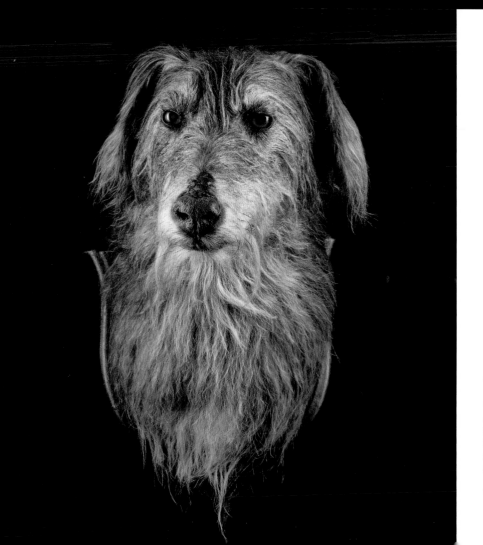

An Impressive Wolfhound

A spectacular and rare Irish wolfhound mounted on an ebonized shield labeled for Rowland Ward. This example from a British collection is extraordinarily lifelike and has an almost wizardly appearance.

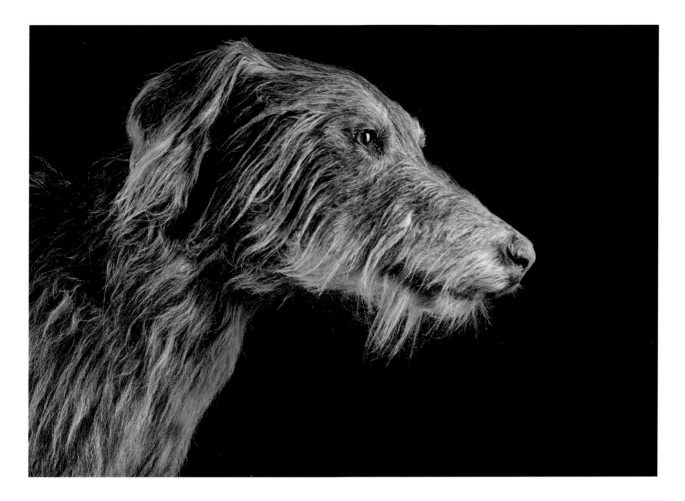

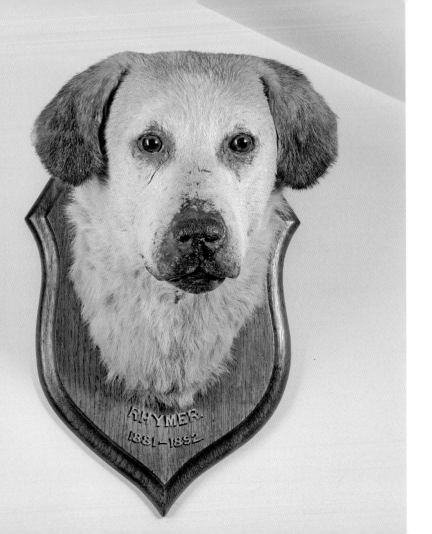

Rhymer the Retriever

A very rare and entirely original head mount
by Victorian master Rowland Ward,
dated 1891–1892 on the plaque. Only a
precious few examples by known makers
have survived to this day and they are,
accordingly, highly prized by collectors of
historical taxidermy.

Winston the Wise

A rather pedestrian-looking mixed-breed dog with a conspicuously flopped left ear, prompting the question of whether the pose was simply creative license on the part of the taxidermist or a deliberate attempt to recreate the preferred posture of the living animal. He has been dubbed Winston the Wise by his current owner, without any particular justification.

Staffordshire Bull Terrier

A head mounted example of a Staffordshire bull terrier or similar breed with original collar and presented on oak shield. From an American collection.

Jack Russell Terrier on Oak Shield

A sprightly Jack Russell terrier presented on an oak shield, this character boasts remarkable symmetry of form.

Tiny Chihuahua Head

Presented on a wooden shield dated 1934, the original owners of this Chihuahua apparently had no room for the entire body and elected to preserve only the head.

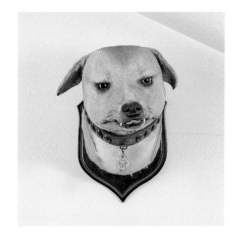
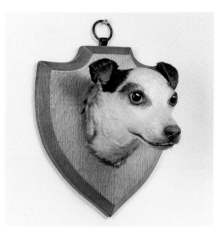
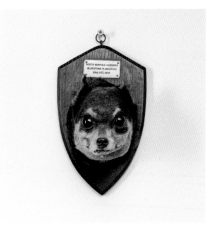

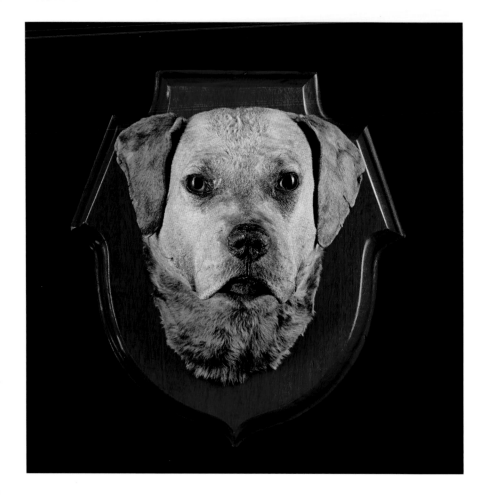

LEFT

A Chesapeake Bay Retriever

A Chesapeake Bay retriever in excellent
condition originating from a U.K.
collection. Early twentieth century.

RIGHT

Antique Terrier

A very fine example of an Airedale
terrier, or similar sporting breed,
preserved as a head mount with
an antique collar, now a cherished
part of an American collection.

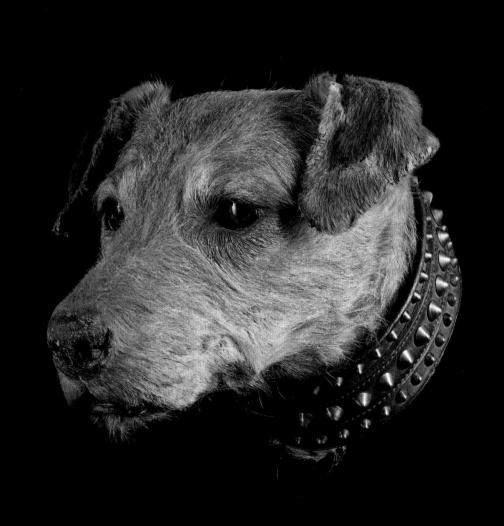

As far as small animals were concerned, nineteenth-century taxidermy enthusiasts had a fondness for cased specimens. A cornucopia of creatures ranging from exotic tropical birds to typical denizens of the European countryside, such as foxes and badgers, made their way into the parlor rooms of England, France, and other European countries encased in glass dioramas. To a lesser degree, this was also true in the United states. There is little doubt that the trend to encase taxidermy specimens in glass was both practical and stylistic in nature. Originating in museums, glass enclosures helped to protect specimens from marauding insects, such as moths and dermestid beetles. Moreover, such cases afforded taxidermists with the opportunity to try their hand at recreating scenic natural environments with a combination of painting and sculpting techniques. Certain studios, like Peter Spicer & Sons, of Leamington Spa, England, became particularly well-known for their ability to seamlessly blend painted backgrounds scenes with foreground elements such as faux rocks, grasses, and branches.

For their part, canine companions did not escape the contemporary fondness for elaborate glass enclosures. Like their less obsequious wild cousins, many deceased pets were similarly entombed in naturalistic dioramas. Some were even displayed along with birds, insects, or other fauna. However, a great many more were preserved in more comfortable and even lavish surroundings with ornate velvet cushions or brocade fabrics festooned with braided rope accents. Whether these dogs actually enjoyed such a luxurious and pampered existence during their living years, we will likely never know, but it is abundantly clear that they remained cherished long after the demise of their original owners.

III
JUST ENCASED

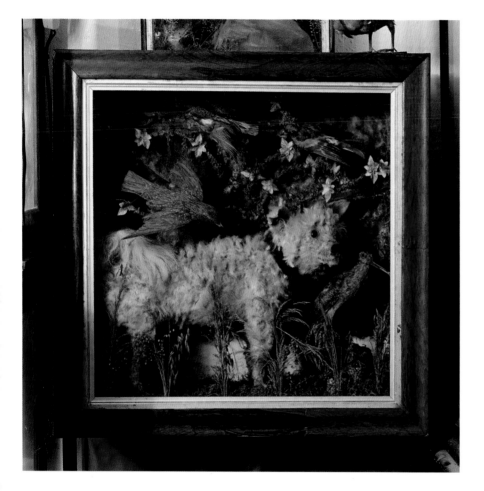

LEFT

A Lapdog in the Wild
A very unusual and folksy presentation
of a white lapdog, possibly a poodle
or bichon type, in a naturalistic
display with accompanying birds.
Late nineteenth century.

RIGHT

Wall of Dogs
An impressive assemblage of twenty-seven
glass-encased antique specimens
representing a diverse variety of breeds
and stylistic choices, this group eclipses
the wall of dogs previously on display at
Brooklyn's now-shuttered Morbid Anatomy
Museum that inspired the creation of
this book. The original version of the wall
featured nineteen individual specimens,
the majority of which were presented in
glass cases.

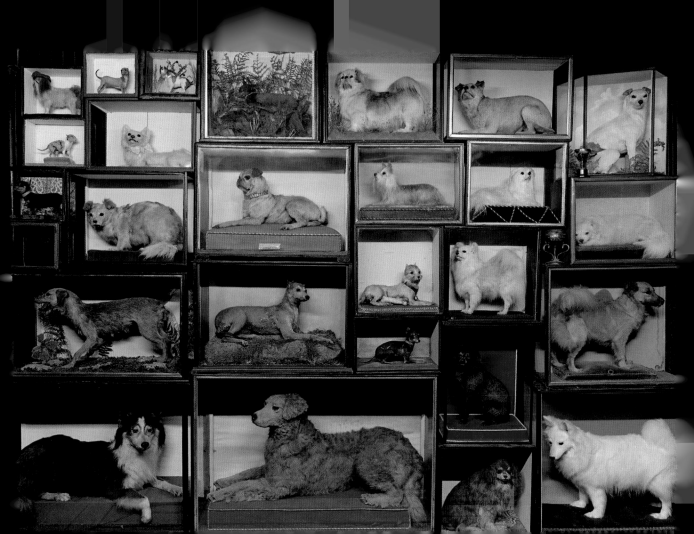

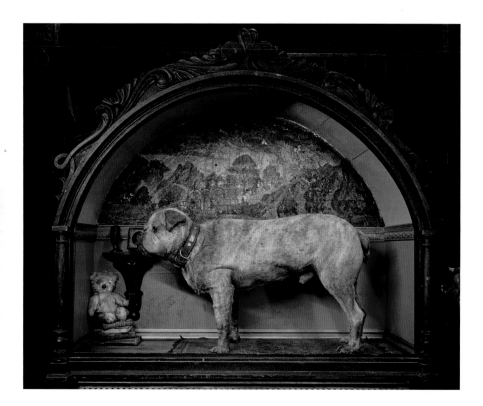

Antique Brindle Bulldog

A wonderful example of a full-mount
brindle bulldog, deaccessioned from
a Texas museum, and now displayed
in an elaborate antique diorama
that was likely a religious reliquary.

Shocked Spaniel

A bewildered-looking example of an antique
cocker spaniel whose facial expression
appears to answer a timeless question,
namely, "Does anyone know what became
of the hot poker?"

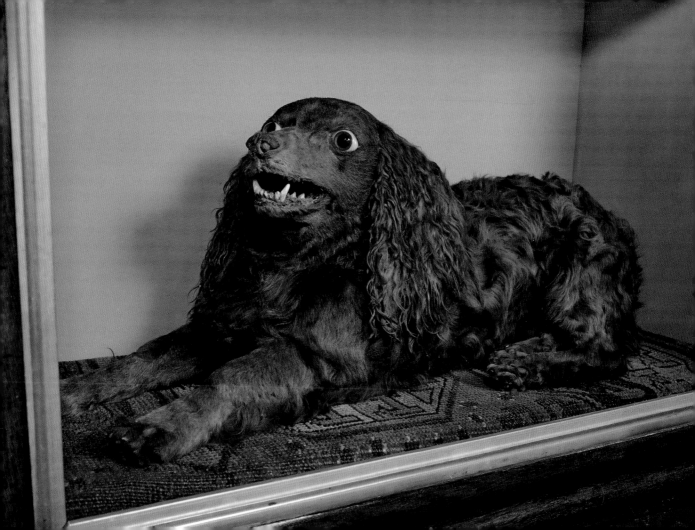

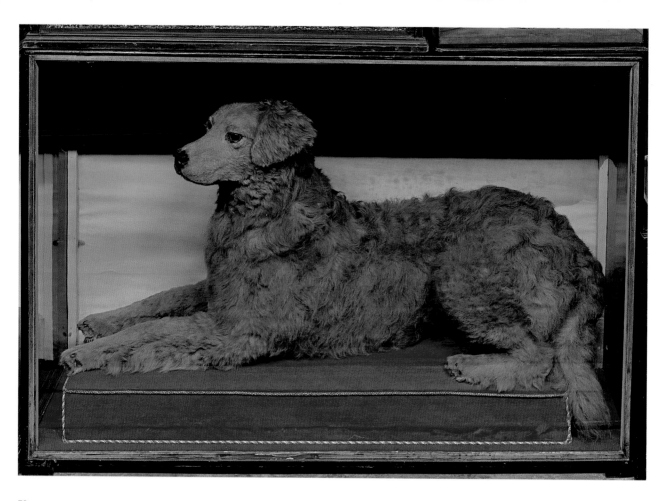

Curly Haired Retriever

A monumental case containing a regal curly-haired retriever, the largest to be featured in this book, is attributed to esteemed taxidermist James Hutchings of Aberystwyth, Wales. Glass-encased antique examples of large breed dogs are exceedingly rare.

A Champion Cavalier King Charles

A very fine Victorian example of a Cavalier King Charles spaniel, dated to the late 1800s and presented in the original glass dome. During her lifetime, this fortunate individual was obviously much adored, and she is decorated with two medallions won at exhibition as a superlative example of this popular breed.

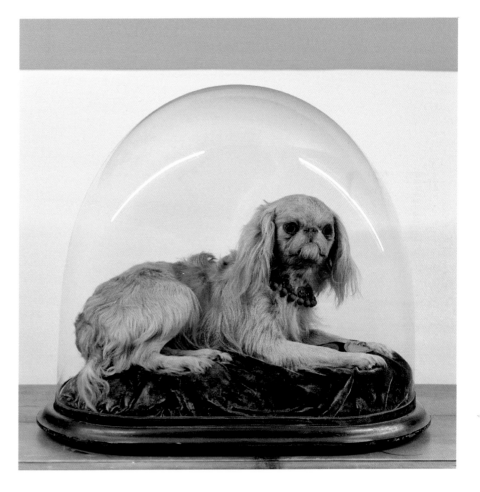

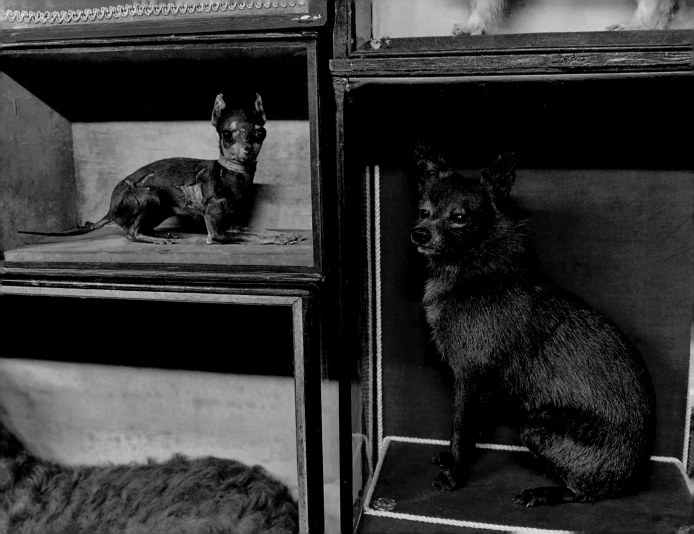

Fingal, the Chihuahua (left)

While the true store of Fingal, the Victorian-era Chihuahua, will likely never be ascertained, he certainly appears to be an alert and mischievous fellow. Age and climate conditions have led to cracking of his once smooth coat, exposing his inner fillings. Fortunately, his charm remains fully intact for all to appreciate.

Belgian Schipperke (right)

An impressive and well-preserved antique example, possibly of a Belgian Schipperke, presented for posterity on an ornate burgundy cushion with gold braid accents within an ebonized glass case.

A Regal Pomeranian

This proud and well-coiffed Pomeranian continues to impress well over one hundred years after its creation.

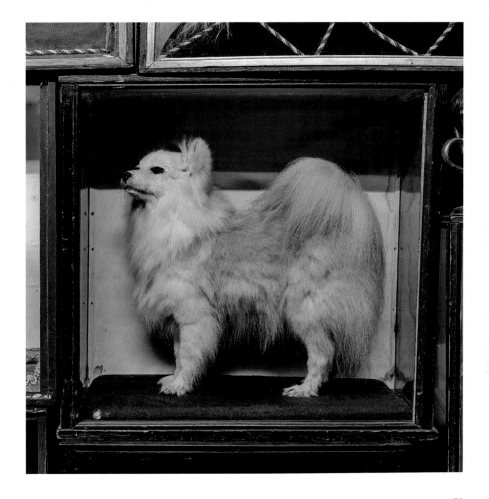

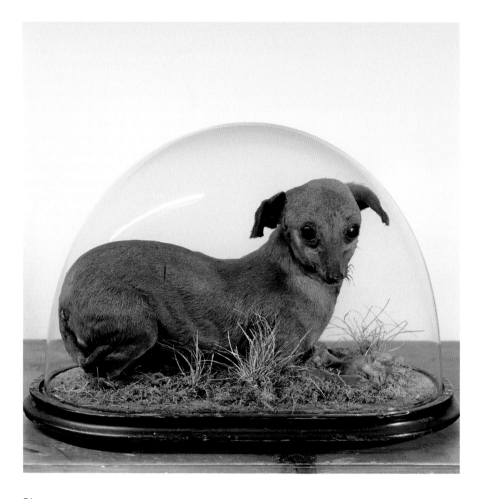

Forlorn Terrier

From a British collection, this rather angry looking terrier dates to the late nineteenth or early twentieth century and is presented in a glass dome.

Doggyland's Finest

A lovely and diminutive Yorkshire Terrier officially named Leazes Mite, with the nickname of Trixie, this impressive example also bore the lofty title of the Best Little Lady in Doggyland, according to her engraved plaque, providing ample testimony to the affection and esteem that surrounded this beauty during her lifetime.

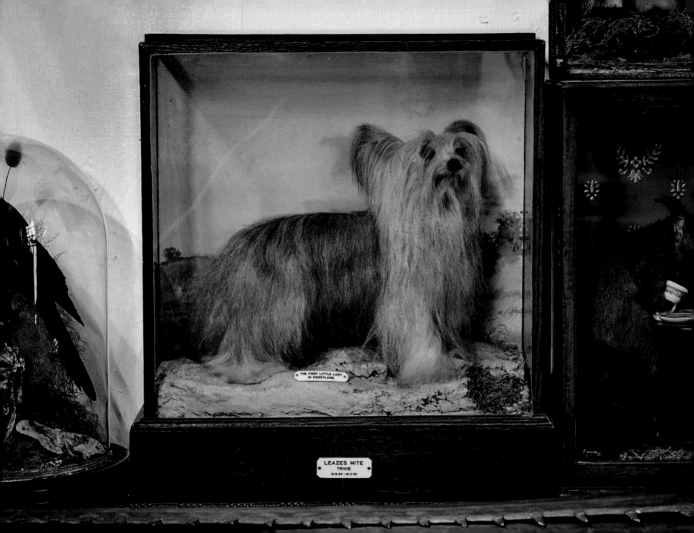

THE FIRST LITTLE LADY
IN DOGGYLAND

LEAZES MITE
TRIXIE

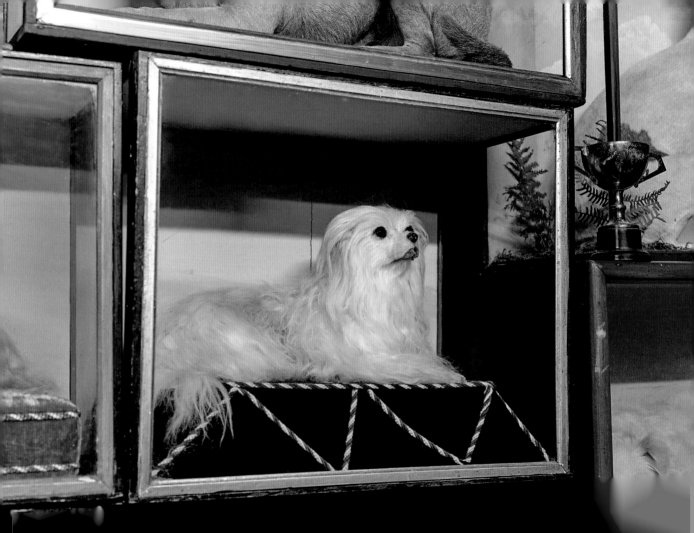

A Pampered Maltese

A fancy toy breed, likely a Maltese, lounging comfortably on an ornate trapezoidal cushion in the manner of a true diva. Late nineteenth century.

An Orange Pomeranian

This example from the early 1900s has the classic Pomeranian color and happens to be flanked by a curious curassow bird. Both the dog and the bird appear to be transfixed by an even more peculiar object out of frame.

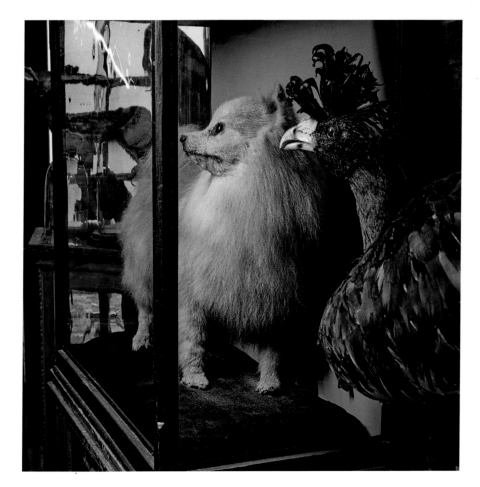

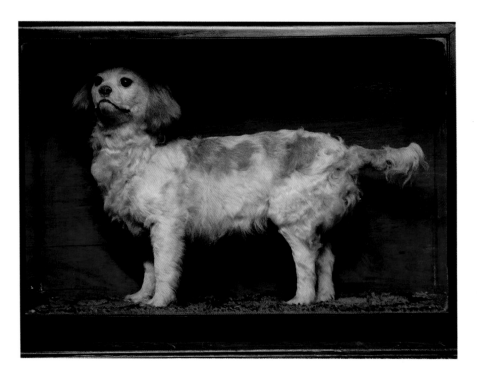

LEFT

Cased Spaniel

An antique white and tan spaniel
displayed on a rug inside of glazed case.
Though typical of the late nineteenth
to early twentieth century style,
this example has unusual charm.

RIGHT

Mr. Scruffles

This decidedly scruffy fellow is set upon a
colorful floral-patterned carpet. It's thick
and matted coat contrasts well with the
colorful pastel background, rendered in the
style of Welsh taxidermist James Hutchings
of Aberystwyth, Wales.

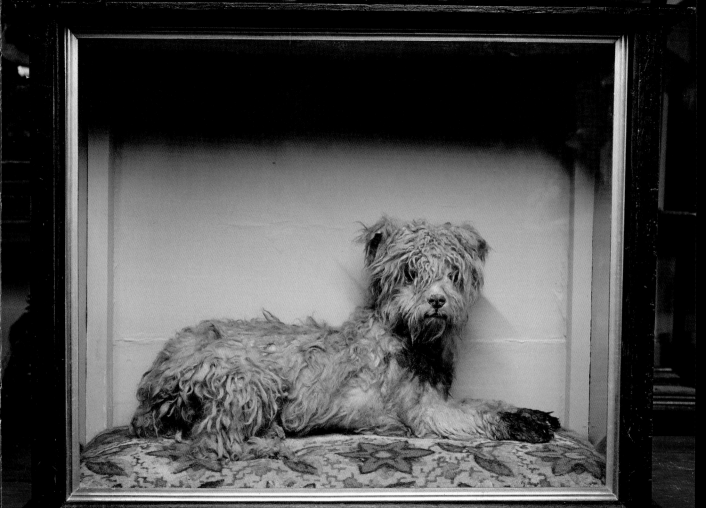

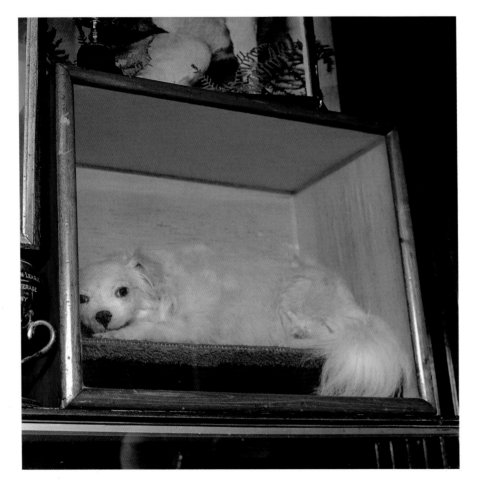

LEFT

Exhausted Spaniel

A demure cream-colored spaniel
in a glass-fronted wooden case.
Early twentieth century.

RIGHT

Reclining Black Dog

A small and well-modeled black dog, breed
unknown, realistically mounted in a relaxed,
but alert pose with erect ears, comfortably
set upon a burgundy pillow.

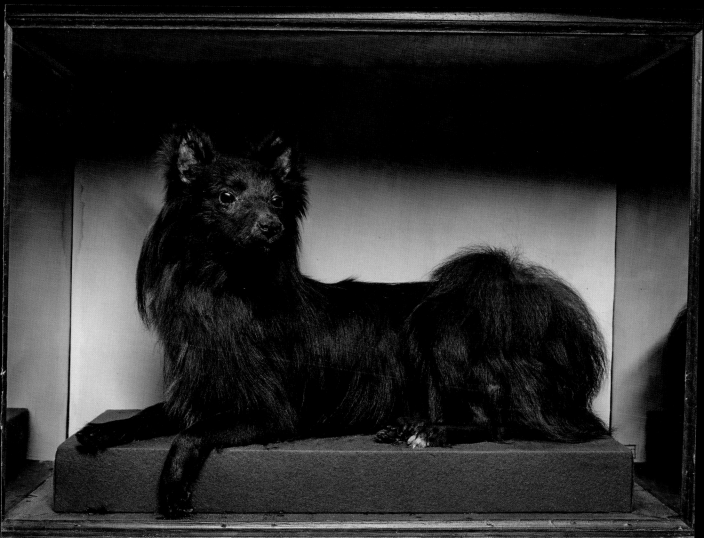

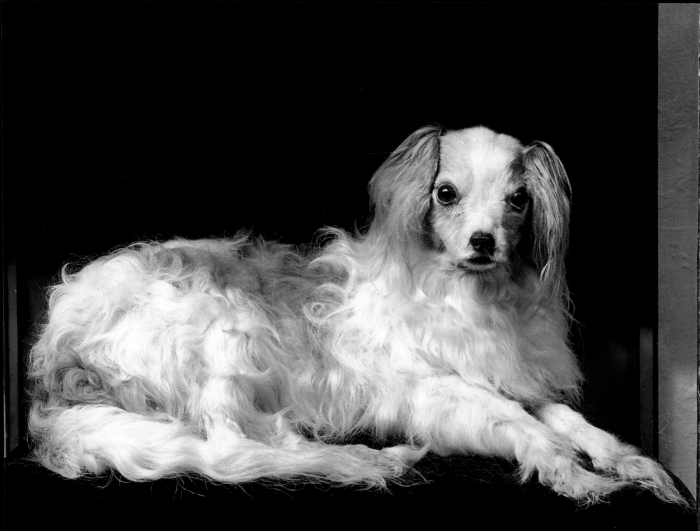

LEFT

Victorian Spaniel

An early example of a Victorian spaniel set against a striking blue background.

RIGHT

Dachshund in Case

A short-haired dachshund in a five-sided glass case. This specimen likely dates from the early to mid-twentieth century and is an excellent example of taxidermy craftsmanship.

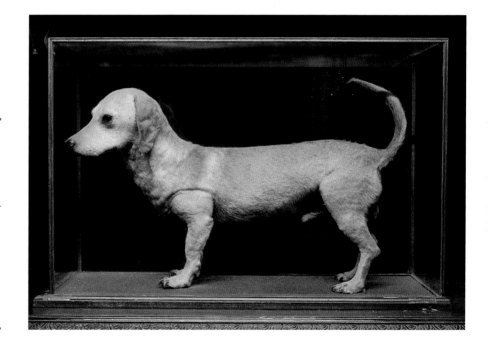

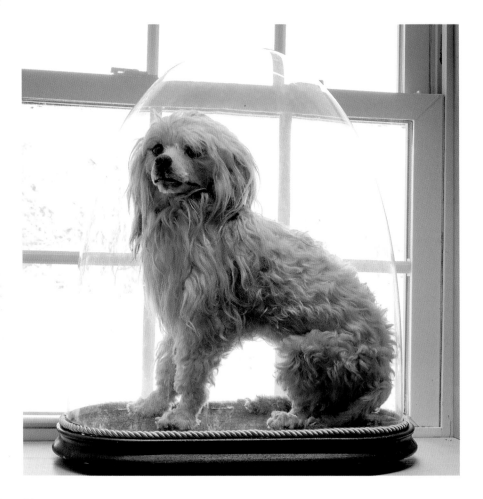

LEFT

French Poodle in Victorian Dome

A fancy and well-preserved French poodle-type dog in a large oval-shaped Victorian-era dome.

RIGHT

Cavalier King Charles Spaniel

An impressive King Charles spaniel in a five-sided glass case, displayed with a stuffed toy rabbit that was undoubtedly a later addition.

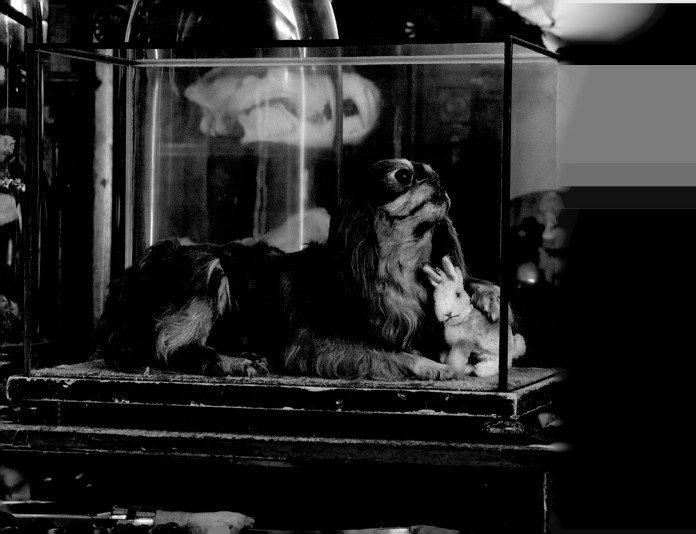

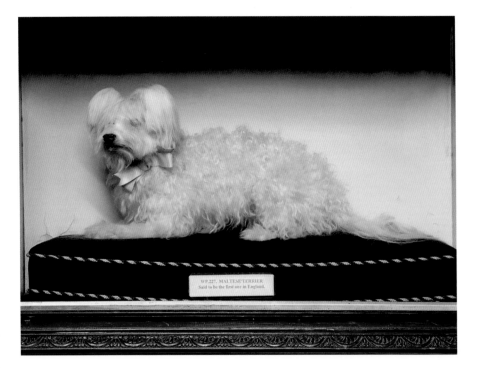

WP.227. MALTESE TERRIER
Said to be the first one in England.

LEFT

Cased Maltese

Though the claim lacks supporting evidence, this nineteenth century Maltese was alleged to have been the very first example of the popular breed to appear in England. Like the cased pug on page 91, this Maltese was also part of the Bonhams 2003 sale of Walter Potter's curiosities.

RIGHT

Antique Yorkshire Terrier

An excellent example of a Yorkshire terrier from a British collection preserved by taxidermist T. E. Mountney.

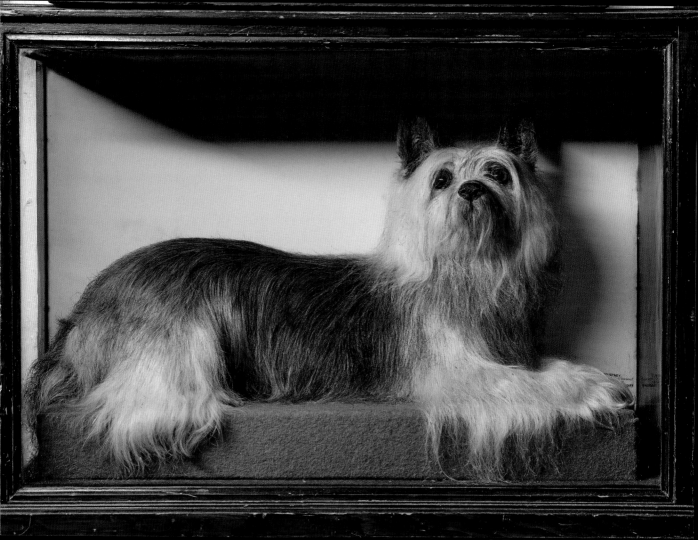

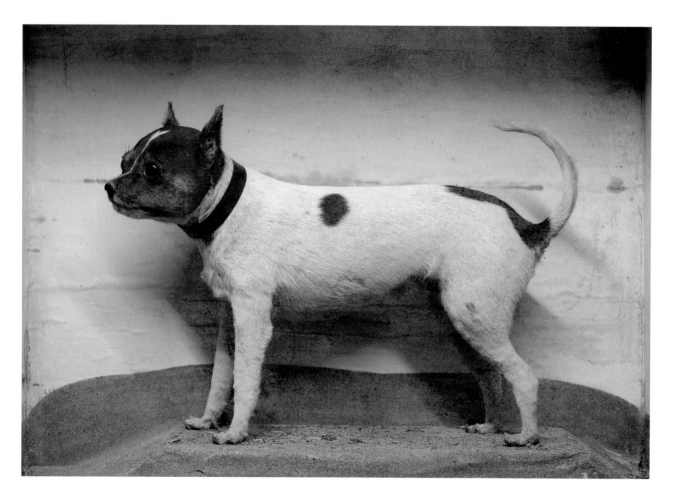

Rodents Beware

This little fellow was likely at least part
rat terrier, which probably made him
quite proficient at vermin control.
Dogs capable of efficient rodent extirpation
were held in especially high esteem
in during Victorian times. Like professional
athletes, some taxidermy examples were
even memorialized with their lifetime
statistics emblazoned on their display cases.

Cased Pug

This Victorian pug was "re-homed" when
Walter Potter's Museum of Curiosities was
liquidated at auction in 2003 by Bonhams
auction house in London. The pug was
sold along with many iconic examples
of historic taxidermy, including famous
anthropomorphic dioramas such as
the Kittens' Wedding and the Rabbit's
Village School, which were meticulously
handcrafted by Walter Potter himself
in the late 1800s.

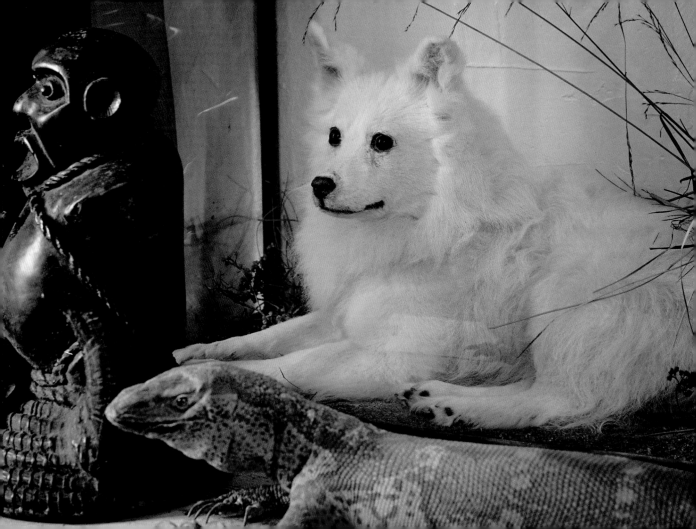

LEFT

White Spitz

An elegant white spitz-type dog, displayed
in a naturalistic diorama and enclosed
within a five-sided glass case. Attributed
to master taxidermist Rowland Ward
and dated from the early 1900s.

RIGHT

A Long-Haired Breed

This regal example of what is likely
a Pekingese or a Tibetan spaniel is presented
on a typical red velvet pillow and mounted
in a playful position. Late nineteenth century.

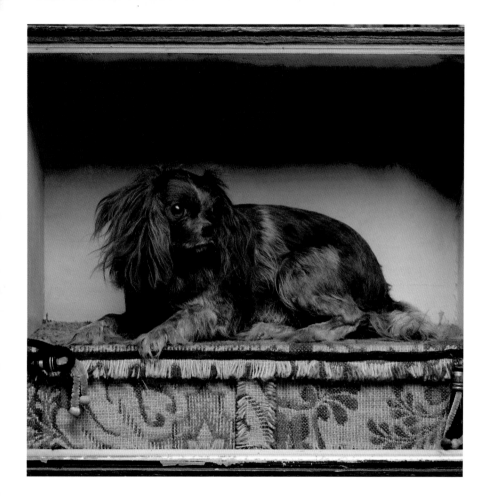

Rose, Cavalier King Charles Spaniel

One of the oldest specimens featured in this work, this spectacular example contains a handwritten label within the case dating it to 1851.

A Cased Terrier with Puppy

This example strikes a rather somber note; the dog likely died while birthing a litter of puppies, one of which has also been preserved.

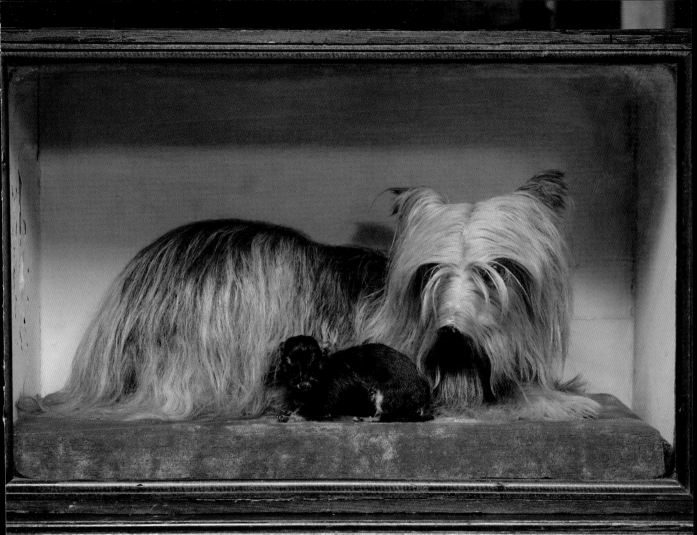

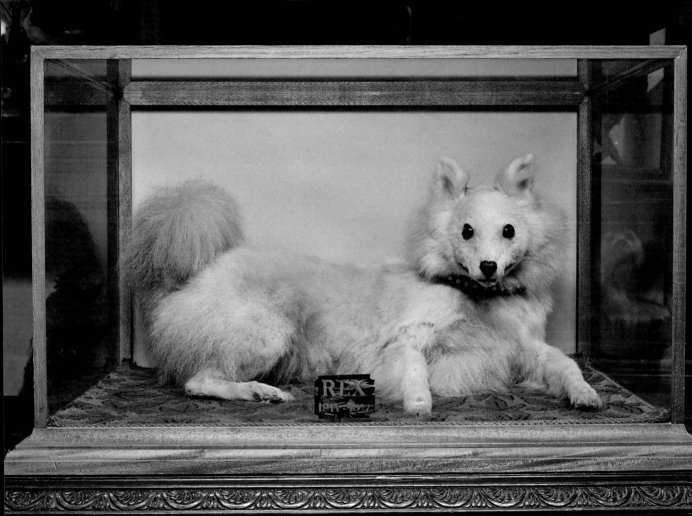

Rex the Predictable

Meet the predictably-named Rex, a 1917
example of cased dog, possibly a spitz or
mixed breed. This example is somewhat
rare in that the majority of pets were
preserved without inscriptions bearing
their names, presumably because most pet
owners choosing this path of remembrance
had little inclination that such details would
be of interest to future generations.

A Magician's Dog?

This cased dog with weasel prey is
presented in a showman's case that
suggests it may have been the companion
of a sideshow performer. However,
the inclusion of the weasel also indicates
that this individual was a capable performer
in his own right when it came to vermin
control. Accordingly, it is likely that the dog
and weasel originally inhabited a more
naturalistic diorama setting and that
the sideshow curtains were a later update.

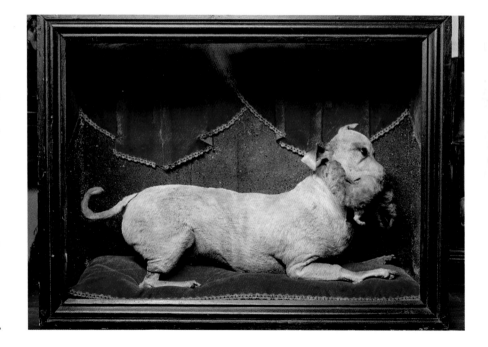

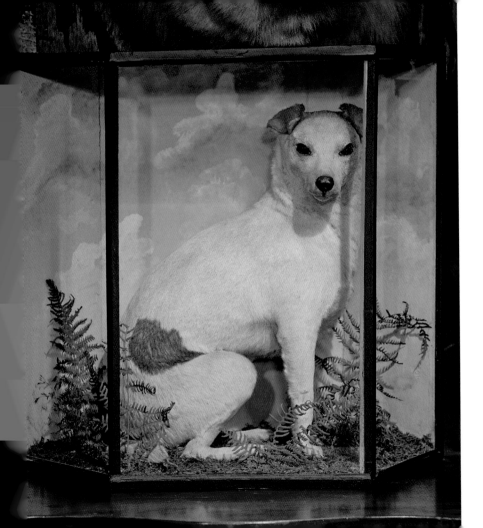

LEFT

Majestic Terrier

An antique terrier presented in a hexagonal glass case, the naturalistic foreground elements and painted background serve to enhance the serene look of this impressive animal.

RIGHT

Pharaoh Hound

A rare Victorian example of a young Pharaoh Hound, this statuesque and distinctive-looking mount looks like it could leap through the glass at any moment.

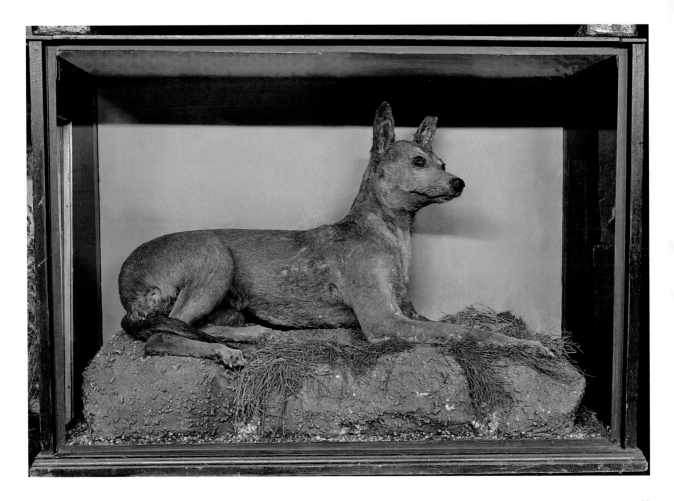

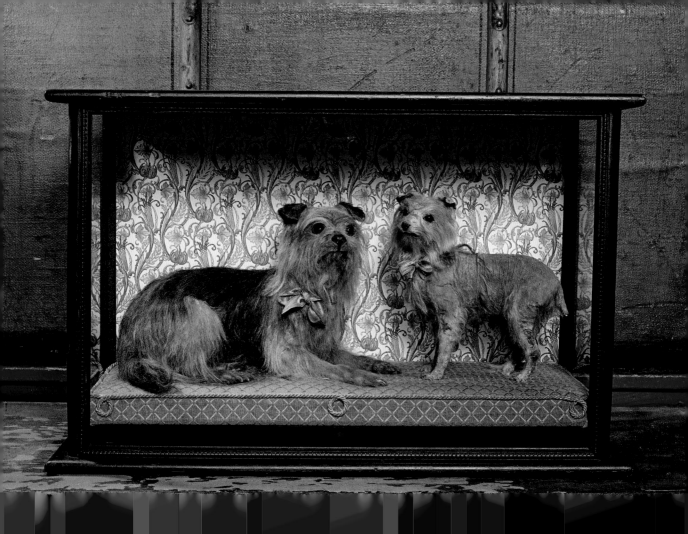

Cased Pair of Yorkies

A rare pairing of two antique terriers
in a single display case adorned with
an ornate teal cushion and floral wallpaper,
in the Victorian style.

Yorkie with Ball

An exemplary Yorkshire terrier in an
elaborate antique case accompanied by
black and red toy ball and standing
atop a gold velvet pillow.

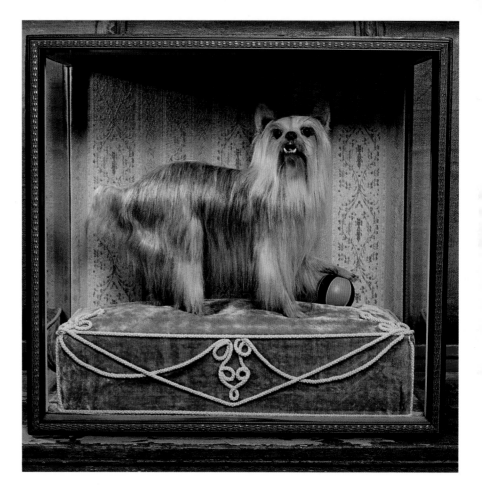

The miniature dog has been the subject of considerable intrigue and fascination since at least the mid-1800s, and not merely among the relatively small circle of enthusiastic taxidermy collectors. In order to understand this phenomenon, we need to bravely venture into a world devoid of smartphones, television, film, cars, and even radio. In this world, the realm of the sensational was relegated to what one could physically observe or read about. This was the era of the Great Exhibition, a veritable tour de force of artistic and scientific wonder that stoked the flames of curiosity among the hoi polloi and royalty alike.

In terms of entertainment value, the mundane and typical would simply not pass muster. Virality, or its Victorian equivalent, required the bizarre and unfathomable.

While there were many authentic examples of truly miniature specimens, both living and ultimately preserved for posterity, it is well-known in taxidermy circles that many so-called miniatures were artistically rendered to meet the insatiable demand for wonder. Many of these were simply stillborn puppies or premature deaths that were skillfully modeled to appear as adult dogs, complete with tiny gilded collars or other ornate accessories.

Though we may not be able to determine which specimens were truly authentic, the obsession with tiny dogs was a product of an era in which the forms of entertainment that we take for granted could scarcely have been contemplated. Yet, despite our technological advances, these diminutive canines continue to captivate the imagination even today.

IV
SMALL PACKAGES

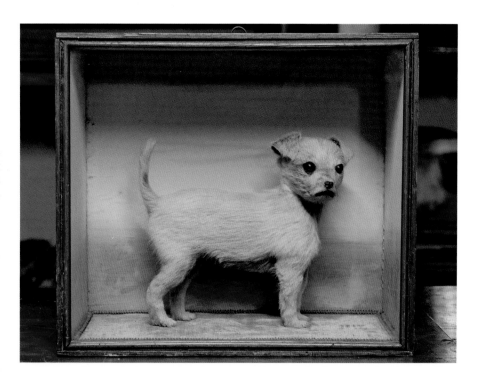

Small White Dog

A small white terrier encased in glass, this unlabeled antique example features a pastel painted background with rose, blue, and yellow hues typical of the style of Victorian makers like James Hutchings of Aberystwyth, Wales.

A Tiny Collection

A group photo featuring eighteen examples of tiny dogs, the majority of which are presented in domes or cases. The mounted deer, otter, and hare feet adorning the wall were a popular form of hunting trophy during the late nineteenth and early twentieth centuries and help to convey the proportionality of these miniature dogs.

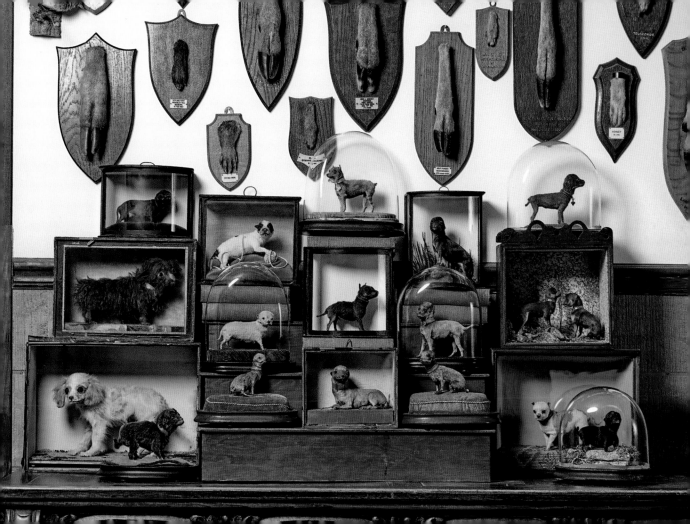

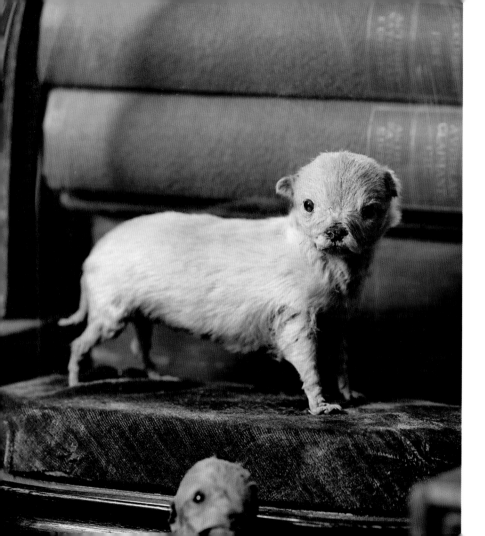

LEFT

Miniature White Dog

A tiny white dog, likely a terrier,
presented in an antique glass dome.

RIGHT

Pair of Miniature Dogs

Likely a pair of stillborn terrier pups
presented as if they were full-grown
adults, this rare and fascinating piece
reputedly formed part of the collection
of the late William "Billy" Jamieson,
the Canadian oddities enthusiast and
dealer famous for his affection for bizarre
and macabre artifacts.

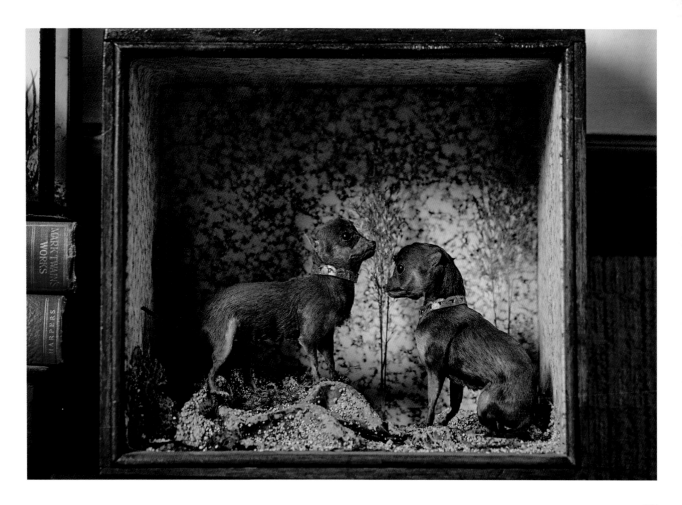

LEFT

Tiny Terrier in Case

A well-preserved antique example
of a miniature dog in its original case,
comfortably sitting on a raised
velvet cushion.

RIGHT

Tiny Black Pug

This tiny puppy with outstretched
tongue appears to be a pug or bulldog.
Though mounted in Victorian style,
the flawless condition of the specimen
suggests a more recent date of creation.

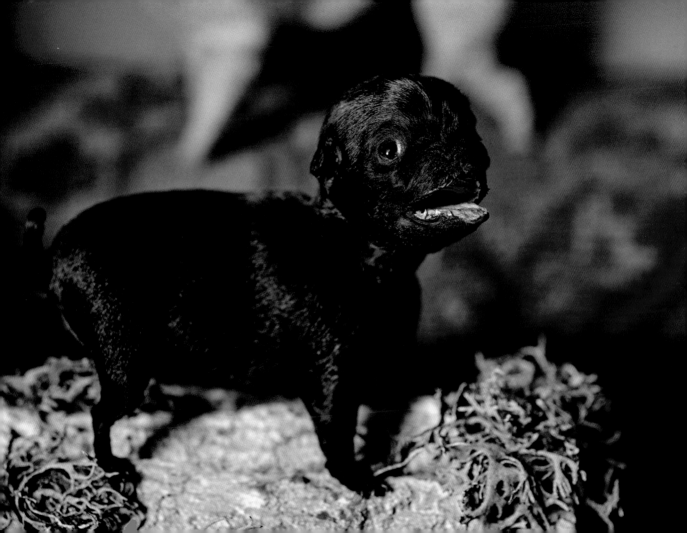

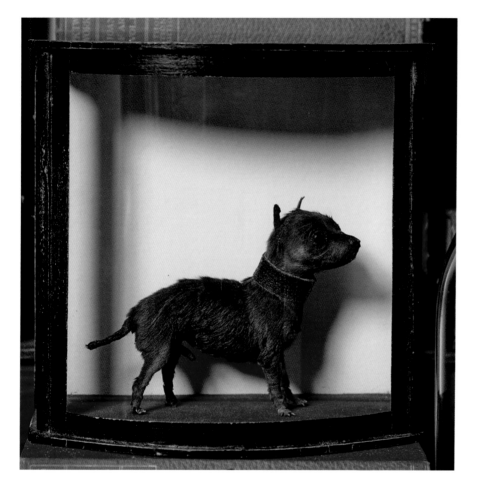

LEFT

"Impressive" Miniature Dog

This unusually well-endowed example of a miniature dog was formerly part of the Candice B. Groot collection. The piece is mounted in the Victorian style, but may be of later origin.

RIGHT

Very Fine Miniature Dog

An exquisite miniature terrier crafted in fine detail, this example is likely a puppy made to appear as if it were a fully grown dog of miniature stature. Unlike similarly sized taxidermy puppies with rounded faces, squat limbs, and inconspicuous ears, examples such as this were designed to inspire wonder and curiosity in the mid-1800s; a reaction many continue to provoke with fidelity some 150 years after their creation.

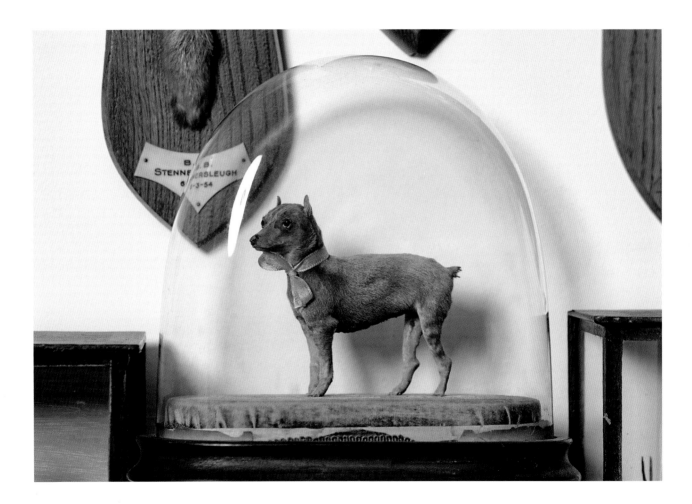

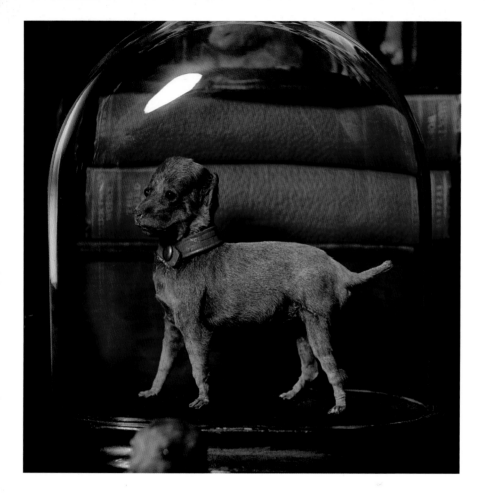

LEFT

Miniature Terrier

A superb and expertly crafted antique miniature in the classic pose of an adult dog, complete with tiny collar. One can easily conjure up a living image of this little prancer trotting down a cobblestone street just barely evading being trampled underfoot by a distracted owner.

RIGHT

Woe Is Me

A very odd example of a Victorian long-haired toy breed with a forlorn expression. This fellow appears as though he could be nearing the tail end of an unproductive negotiation with a recalcitrant owner for just one more morsel from the dinner table.

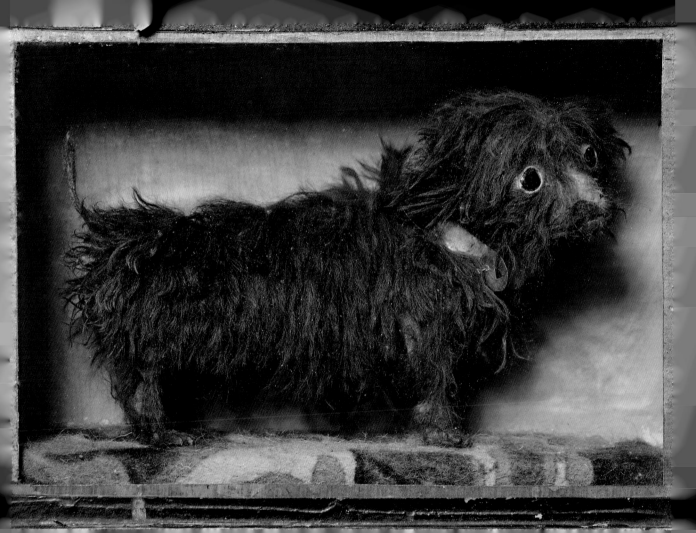

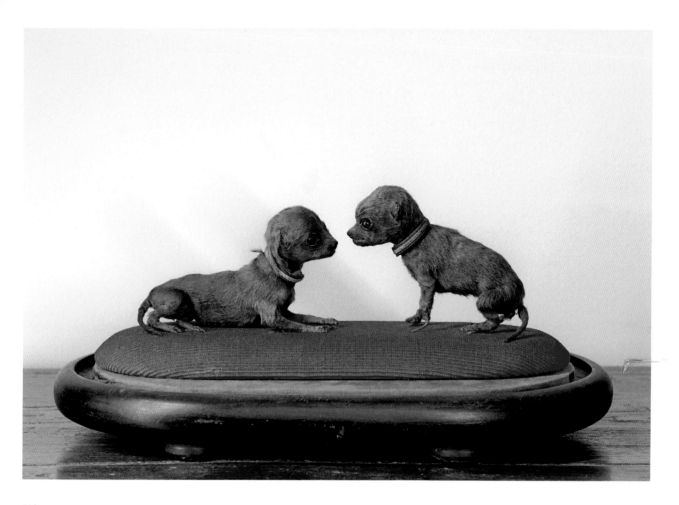

Poor Unfortunates

These two diminutive antique pups are said
to be the stillborn progeny of a terrier bitch
that was also preserved through taxidermy.
From an American collection.

French Miniature Dog

This tiny antique example of a miniature
dog is displayed in a French wedding
display case that, in all likelihood,
was originally designed as a showcase
for another decorative item before
the current resident moved in.

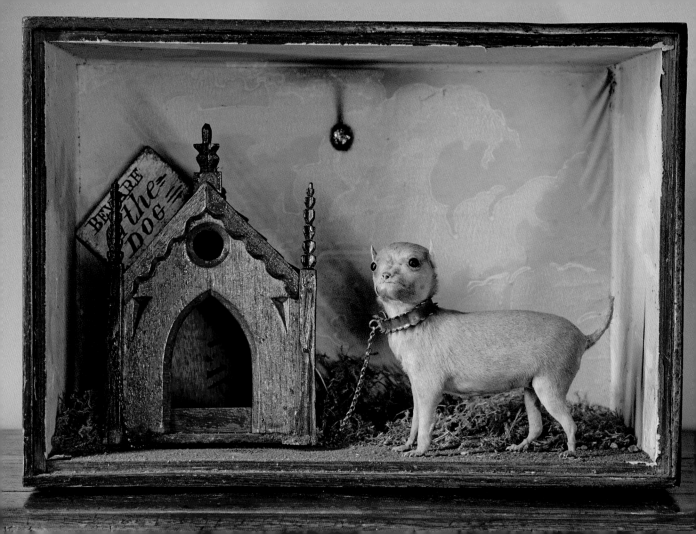

Beware of (Tiny) Dog

Another example of the Victorian obsession
with miniatures, this tiny chap boasts
a rather optimistic view of his prowess
as indicated by the sign adjacent to his dog
house, which has fallen over in the photo.

Miniature Bulldog

This miniature bulldog was likely stillborn,
but like most miniatures of the Victorian
age, was preserved to mimic the appearance
of an adult dog, including details such
as a tiny decorative collar. Late nineteenth
to early twentieth century.

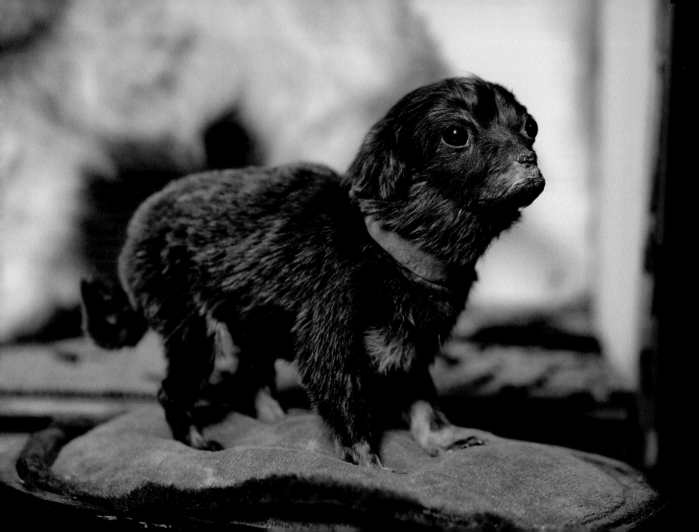

LEFT

What the Fluff?

An unusual specimen of a decidedly
fluffy miniature dog, this particular
individual found his forever home inside
an American cabinet of curiosities.

TOP RIGHT

Tiny Black Puppy

Another example of a tiny black puppy
presented in a bowfront case.

BOTTOM RIGHT

Ball and String

A striking example of a glass-encased
puppy presented as if playing with a ball
of string. Often, historical examples of pet
preservation included a toy that served
the dual purpose of offering a charming
visual enhancement to the scene as well
as a mechanism to alleviate boredom
in the afterlife.

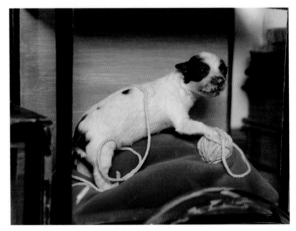

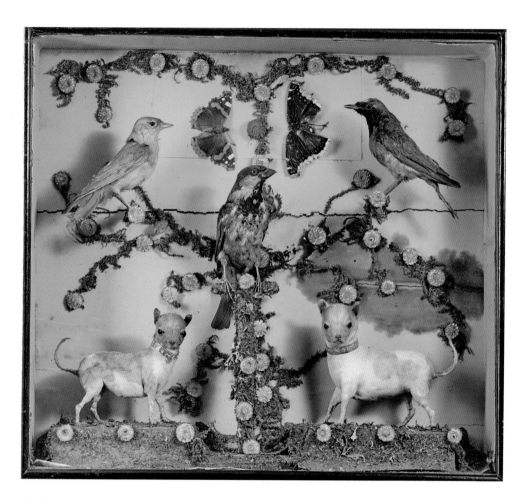

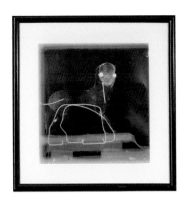

A Rare Pair

An extremely rare example of two miniature dogs presented in the original nineteenth-century display case. The Lilliputian canines in this example are presented along with sparrow-sized birds and butterflies to underscore their miniature scale. The black and white inset photo is an X-ray image of one of the featured dogs that captures the specimen's skull and the wire armature used to create a structure for the handmade mannequin that forms the body under the skin.

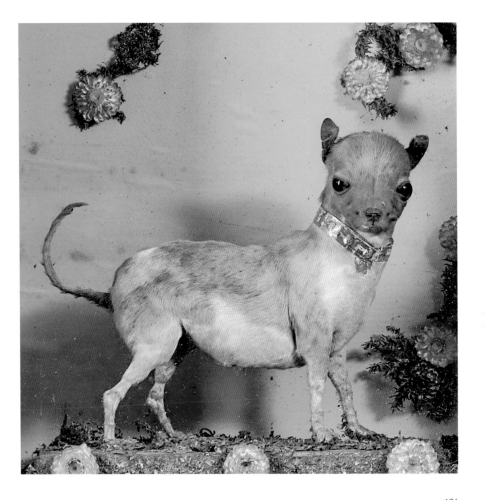

As with living people, certain taxidermy dogs simply break the mold. The examples in this section defy conventional wisdom and push the limits of whatever might pass for normalcy even in the context of esoteric and obscure subject matter. They run the gamut from questionable artistic decisions to "freak" specimens that one might expect to see in a circus sideshow. A few interlopers that have managed to infiltrate these pages are not domestic dogs at all. Regardless of the specific reasons for their inclusion, these examples underscore the bizarre lengths that both the original and modern-day owners are willing to go in order to preserve and protect their beloved.

V
ODDS & ENDS

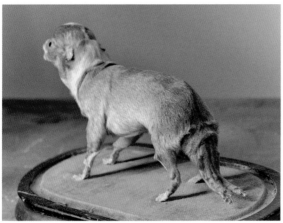

Victorian Six-Legged Puppy

This intriguing Victorian-era specimen died at an early age, possibly as a complication of polymelia, the condition of having more than the standard number of limbs. Polymelia is more common in domesticated farm animals, such as sheep, cows, and pigs, and is surprisingly rare in dogs.

RIGHT

Hexapod Pup

This later example of a hexapod pup was born with six legs and lived only a short while after birth. Lovingly presented for posterity on a red satin pillow.

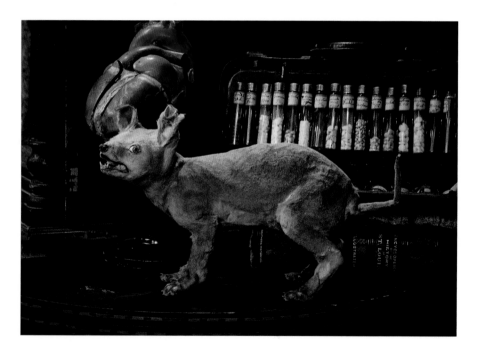

Ol' Neville

Another canine misfit, this meme-worthy chap was given the name Neville by a former owner and gathered some internet acclaim after being featured at the Morbid Anatomy Museum's taxidermy exhibit in the "Crap Taxidermy" section, the tile of which was inspired by Kat Su's eponymous 2014 book. Though originally believed to be a dog, Neville may be disappointed to learn his true identity: a fox that had an encounter with the business end of a hair clipper.

A Rare Chupacabra

This peculiar taxidermy specimen was purchased by its owner as a Mexican hairless dog, but close inspection calls this identification into question. By appearance alone, one could be forgiven for coming to the conclusion that the preserved creature is an example of a chupacabra, or goat sucker, the legendary cryptozooid said to inhabit the warmer regions of the Americas. In fact, it appears likely that it may in fact be a fox that has lost its fur coat due to inadequate preservation techniques or perhaps a condition such as mange.

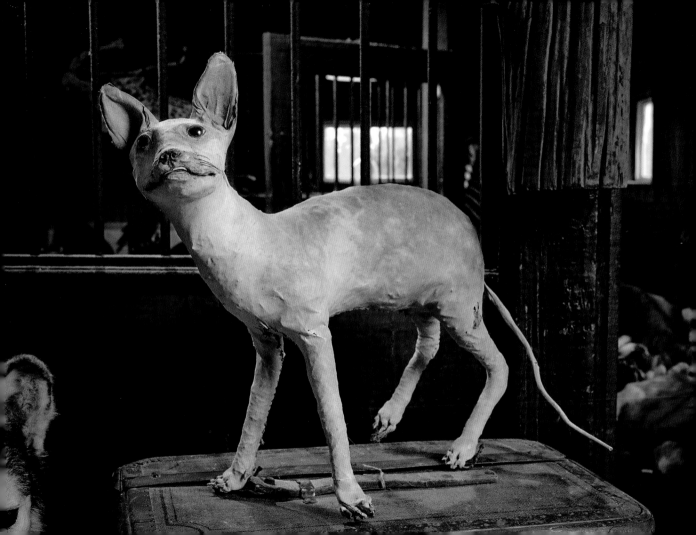

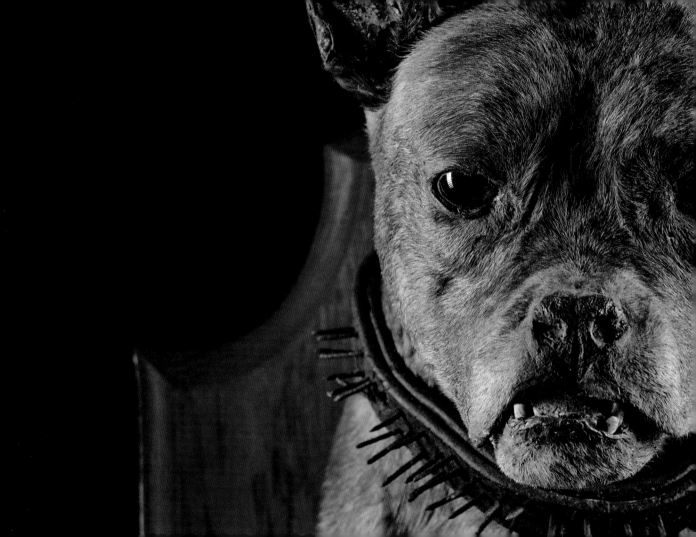

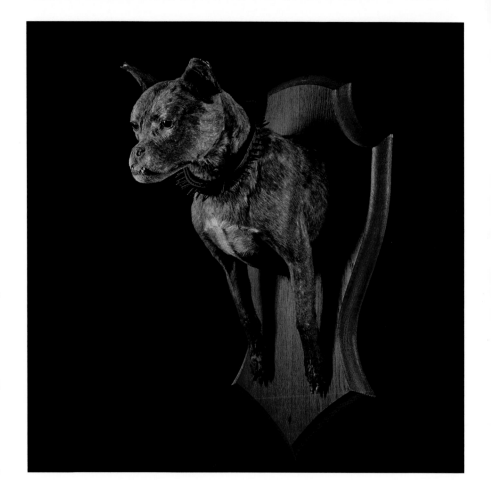

French Bulldog

An antique French Bulldog, in a very
rare half-mount presentation in which
the head, chest and forelimbs of the animal
are presented on an oaken shield.
While half-mounts were often commissioned
for game animals to convey a sense of the
grandeur of the living form while giving
a nod to spatial constraints, precious
few dogs mounted in this manner have
withstood the test of time.

LEFT

Dachshund Rug

The elongated, flattened body of this dachshund rug is especially provocative. It would certainly be fair to wonder how seeing a beloved pet preserved as a puppy pancake could possibly bring solace to a bereaved human owner, but the taxidermied Persian cat seems quite satisfied with the results.

RIGHT

Antique Sporting Dog Rugs

Few examples of postmortem pet preservation inspire as much curiosity (and contempt) as the dog rug. These antique examples from the early 1900s are no exception to the rule. Though we are quite accustomed to similar presentations of predatory animals such as bears, seeing dogs displayed in this manner transports most people into uncomfortable territory.

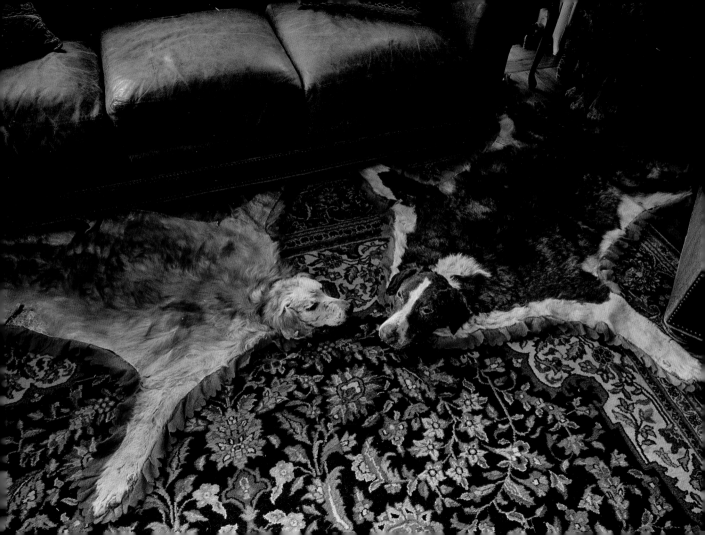

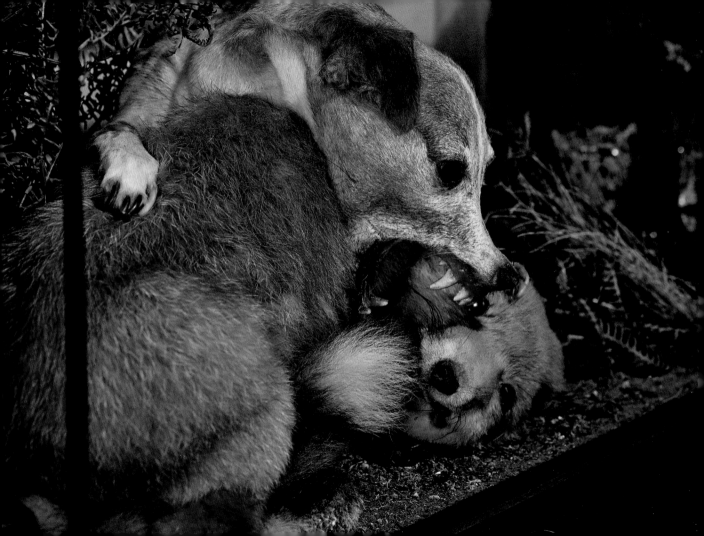

Clash of Mignons

Attributed to British taxidermist Rowland Ward, this dramatic fox vs. terrier diorama in a five-sided glass display case has no shortage of action. The raw aggression of the terrier is matched only by the utter resignation of the exhausted fox.

All Hail Caesar

While dog skulls were often preserved for veterinary study and other educational purposes, they are rare as mementos of deceased pets. In this case, the skull of Caesar, a Doberman Pinscher, is presented in an antique glass display case. While not technically considered taxidermy due to the absence of the dog's skin in the preparation, this is a somewhat macabre example of the commitment that some owners have to preserving the memories of their four-legged family members for posterity.

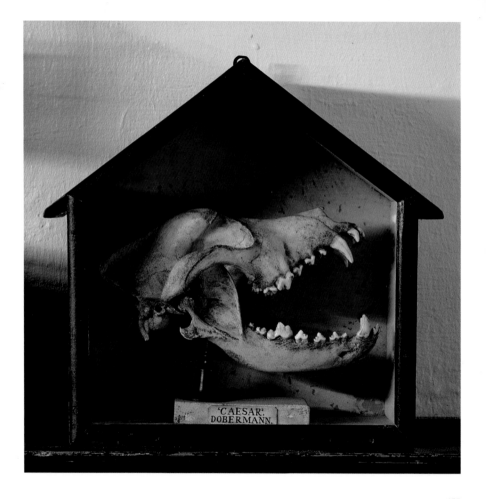

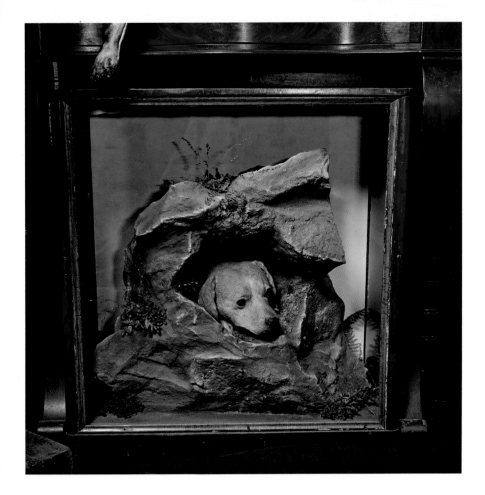

LEFT

An Unusual Hound's Head

A peculiar, but well-crafted example
of a hound peeking out from behind a faux
rock formation and enclosed in an elaborate
burl wood case. Why the taxidermist
(or owner) chose to feature only the head
and forelimbs we will never know,
but it is likely that this individual was
a noteworthy hunter in its day.

RIGHT

Accidents Happen

This fanciful contemporary piece by U.K.-
based taxidermist Colin Griffith captures
the antics of two mischievous border collie
pups causing a bit of havoc in the kitchen,
knocking over a table and a tin of biscuits.

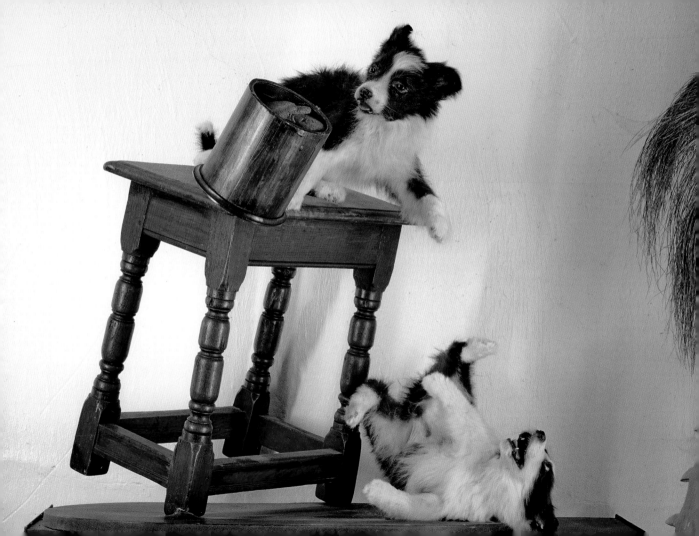

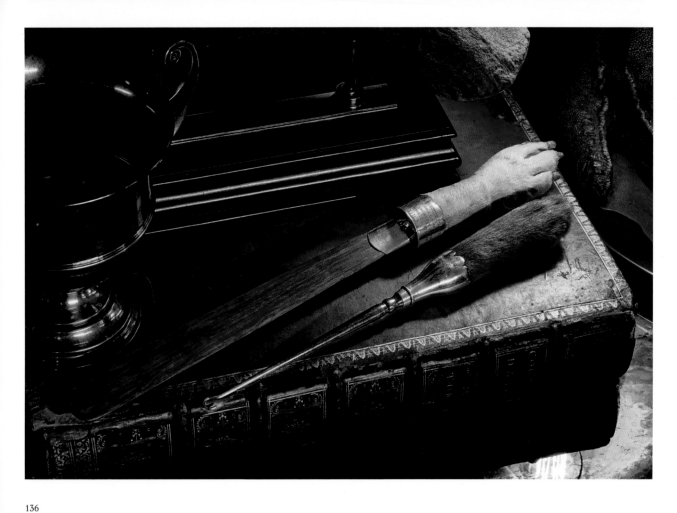

A Royal Dog-Paw Page Turner

This extremely rare dog-paw page turner
(on left) with royal provenance was likely
commissioned to memorialize the passing
of Fritz, a cherished Italian greyhound,
and given as a gift from Her Imperial
Highness Victoria, German empress
and Queen of Prussia (1840–1901) to
Frederick III, German Emperor and king
of Prussia (1831–1888). In addition to
bearing the maker's mark of Rowland Ward,
the engraved inscription reads, "Fritz. born
at Potsdam, July 1875. Died at Aldershot.
April 7 1884. Gift of H.I.H Crown Princess
of Germany."

Dog-Paw Button Hook

A Victorian dog-paw buttonhook (on right)
inscribed with the name Whiskey and dated
1900. Buttonhooks were used to help lace
ladies' shoes and clothing and occasionally
featured taxidermy adornments intended
to commemorate small-game hunting
expeditions. Examples with dog paws
are highly unusual.

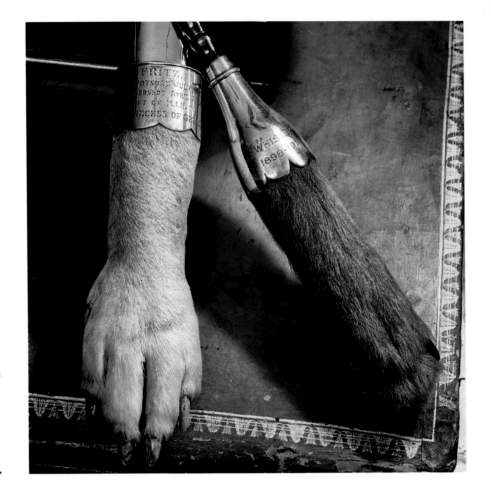

Stash Box Dog

At first glance, this tabletop head mount looks rather typical, but it holds an unexpected surprise: lifting the upper portion of the head reveals a hidden stash box, perhaps used for tobacco.

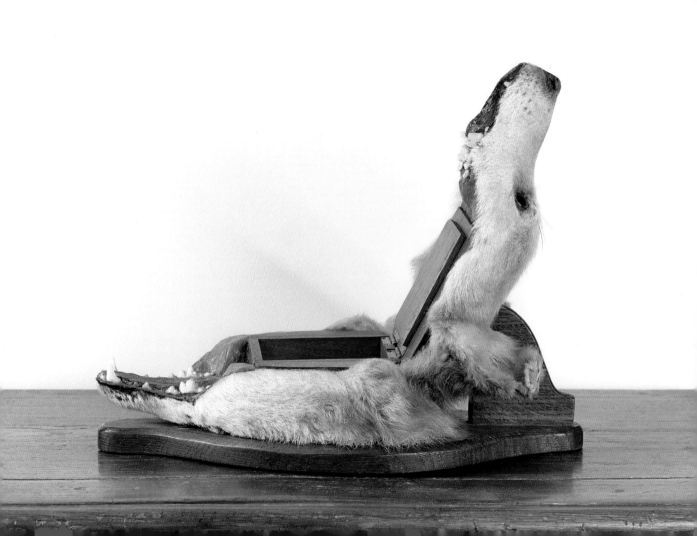

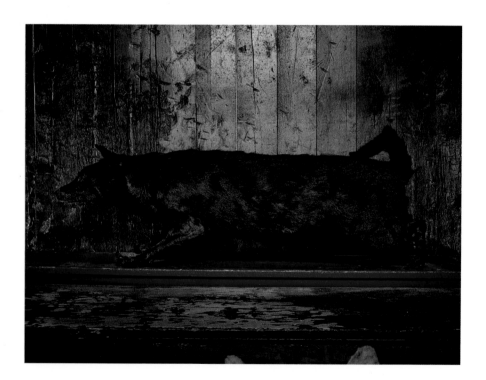

Sausage Dog

At times, one is forced to acknowledge the awkward truth that some pets would have been better off had their owners not realized preservation through the art taxidermy was an option. I know what you're thinking, but no, this is not one of those times, and frankly, I think you've hurt her feelings.

The Saddest Spaniel

This early and rather primitive example of what appears to be a King Charles Spaniel met a truly tragic end in the mid-1800s when it was stoned to death by marauding children. The unfortunate animal's fate was immortalized not only through the taxidermy itself, but also through the accompanying handstitched poem, which foretells karmic retribution in the hereafter: "Oh thou brutish creature, to kill a dog like me, leave him to the judgment day and rewarded he will be." Indeed.

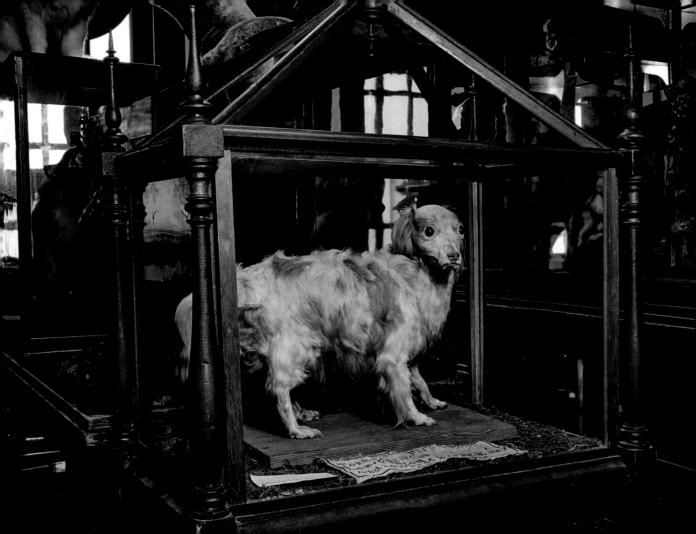

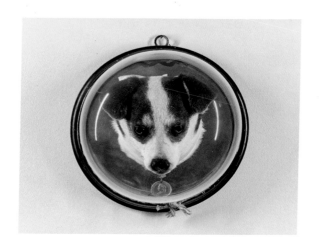

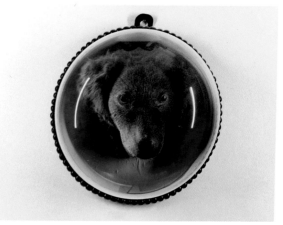

A Trio of Wall Dome Dogs

Three beguiling and rare examples of dog heads in sealed-glass domes designed to be hung on walls. This style of mounting was quite typical of ornamental specimens such as exotic birds and offered obvious advantages as a means to protect against insect infestations, dust accumulation, or other undesirable afflictions, such as excessive moisture. Dogs, however, were rarely preserved in this manner, perhaps because it created the impression that they were preparing for deep-sea expedition, or, for the more forward-looking, an interstellar voyage.